© 2013 by Paula Kay Shelton. The book author retains sole copyright to his or her contributions to this book.

Scriptures taken from the Holy Bible, New International Version ®, NIV® Copyright © 1973, 1978, 1984, 2011 by Biblica, Inc® Used by permission. All rights reserved worldwide.

Scripture taken from the
NEW AMERICAN STANDARD BIBLE®,
© Copyright 1960, 1962, 1963, 1968, 1971, 1972, 1973, 1975, 1977, 1995 by The Lockman Foundation
Used by permission.

Royal Telephone Line © 2013

Pocket Version of God Given Eye

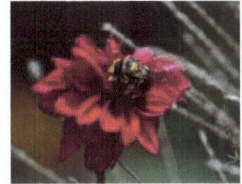

God Given Eye

Visualizing God's Word
Pocket Edition

by Paula Kay Shelton

In loving memory of my Dad, Odis Roosevelt Shelton
I'll see you later

Thank you my Lord and Savior, Jesus Christ for carrying me through the darkest times and pointing my camera to the beauty our God has created.

Father, I pray that each page of this book is a blessing to the eyes of the viewer. May these images encourage my brothers and sisters that beauty and love still exist with your leadership. Remind us Father that your word is found when we praise your name.
In Jesus name, I pray.
Amen

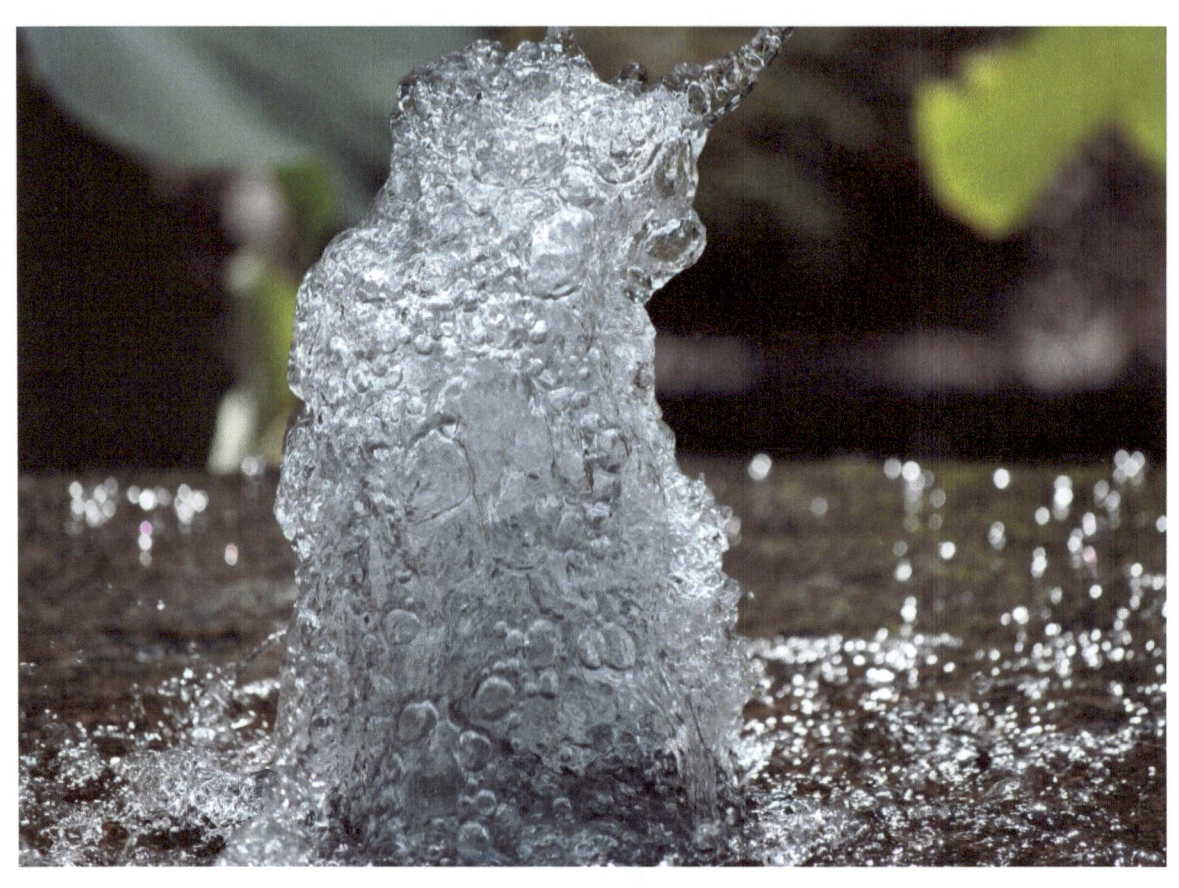

Jesus wept.
John 11:35

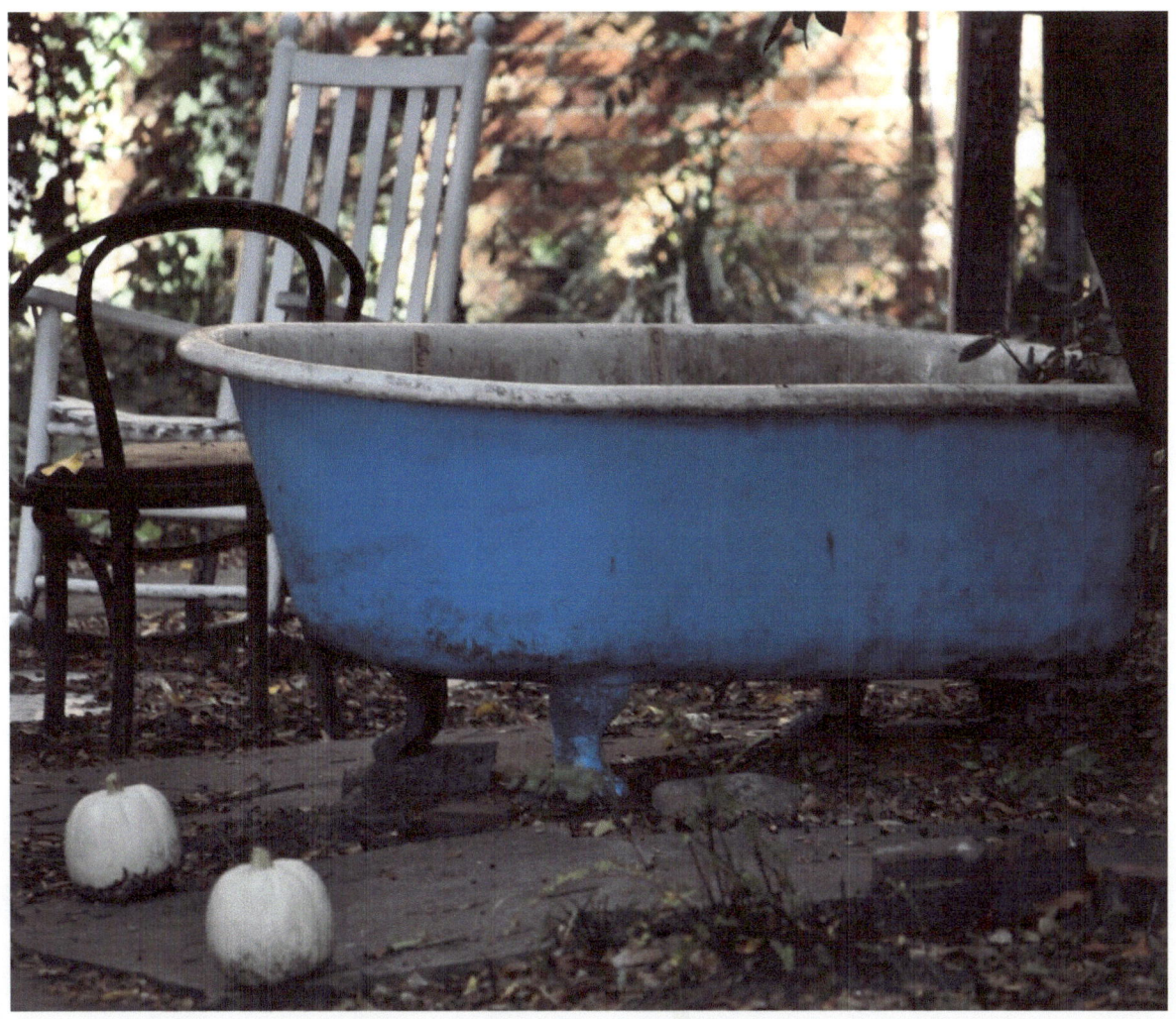

For we know that if the earthly tent we live in is destroyed, we have a building from God, an eternal house in heaven, not built by human hands.

2 Corinthians 5:1

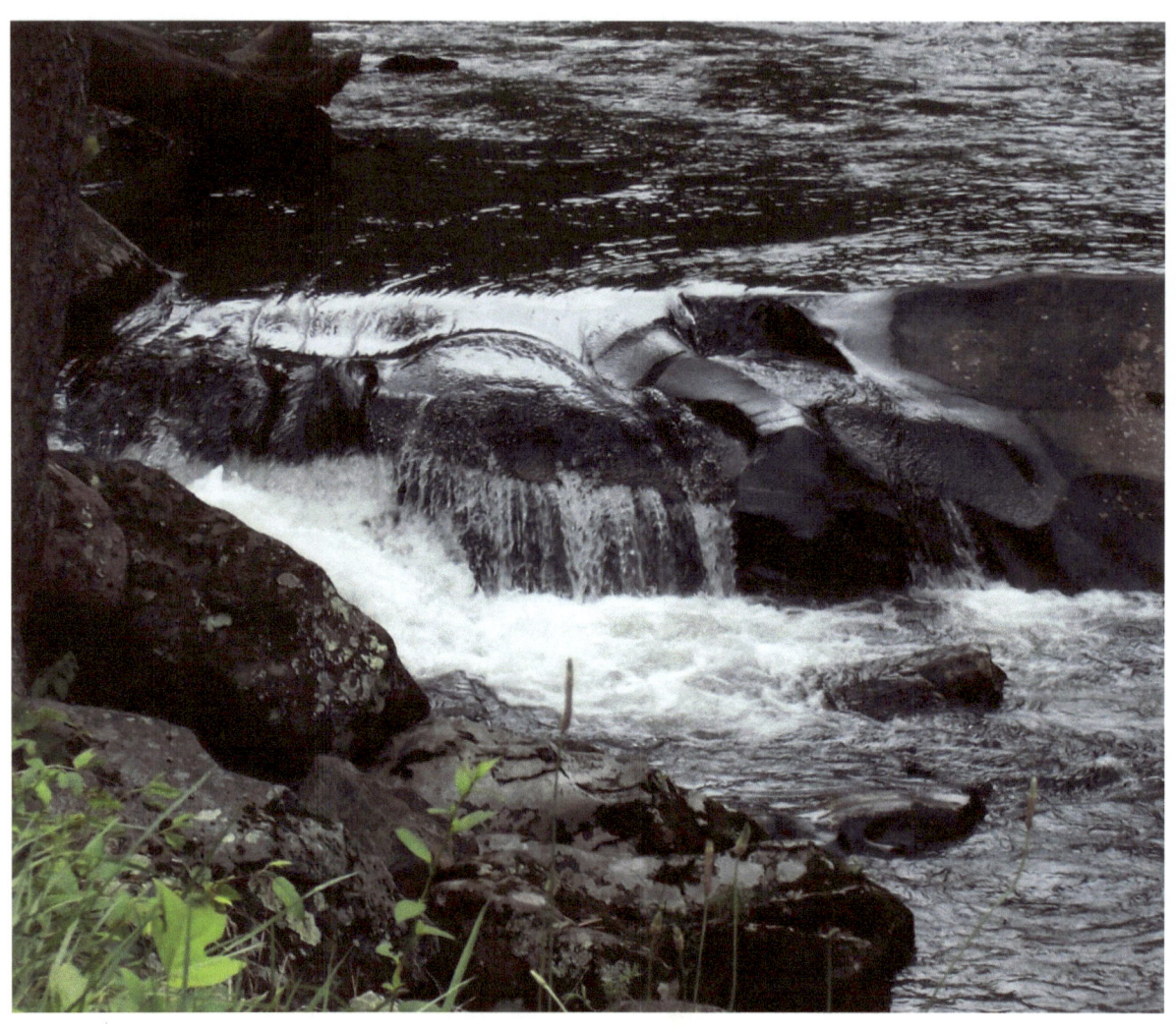

He makes springs pour water into the ravines; it
flows between the mountains.
Psalm 104:10

Then he got into the boat and his disciples followed him. Suddenly a furious storm came up on the lake, so that the waves swept over the boat. But Jesus was sleeping. The disciples went and woke him, saying, "Lord, save us! We're going to drown!"

He replied, "You of little faith, why are you so afraid?" Then he got up and rebuked the winds and the waves, and it was completely calm.
Matthew 8:23-26

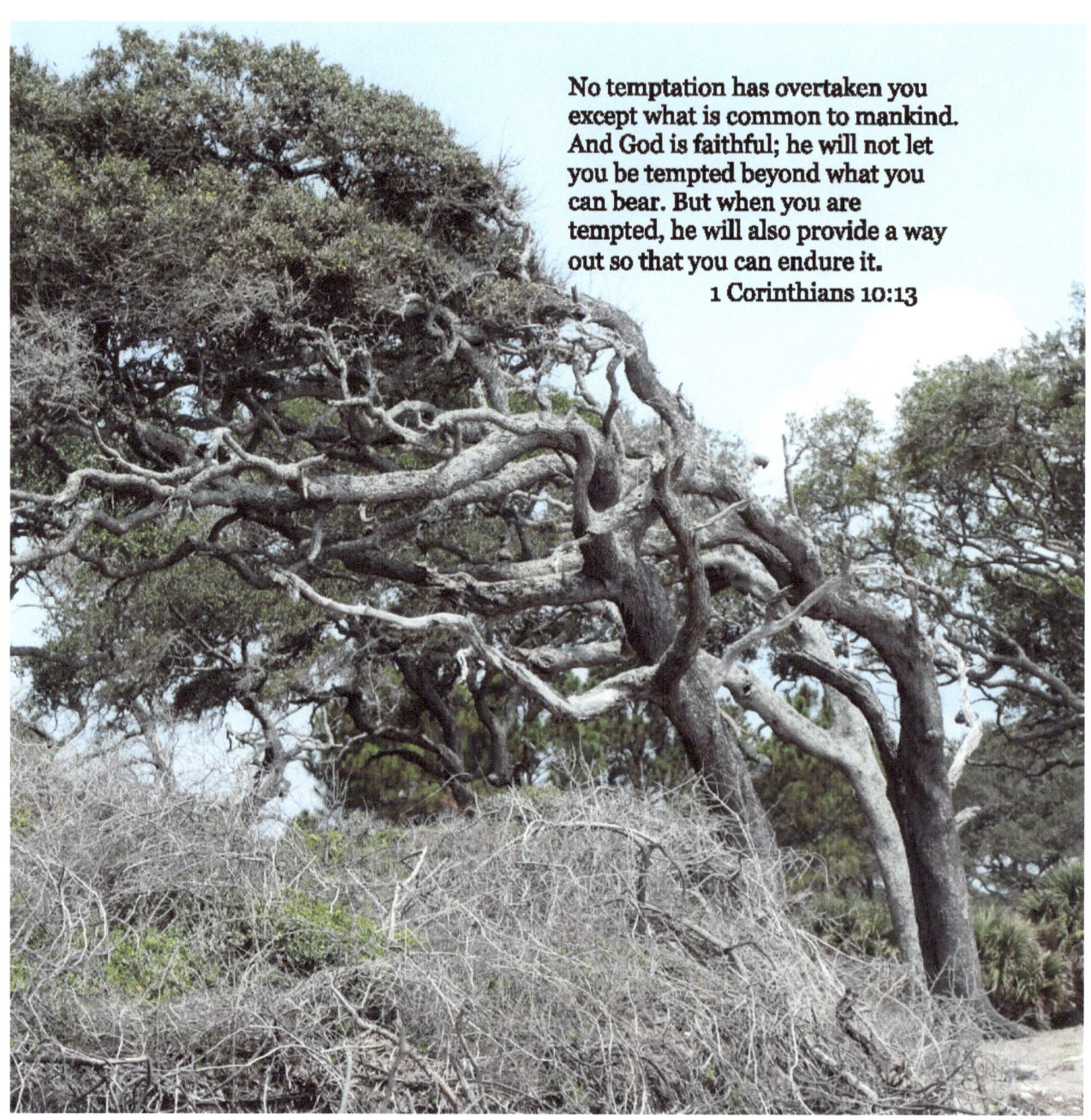

God Given Eye

I will give you a new heart and put a new spirit in you; I will remove from you your heart of stone and give you a heart of flesh.
Ezekiel 36:26

Remember the days of old; consider the generations long past. Ask your father and he will tell you, your elders, and they will explain to you.

Deuteronomy 32:7

Even to your
old age and
gray hairs I am
he, I am he who
will sustain
you.
I have made
you and I will
carry you; I will
sustain you and
I will rescue
you.

Isaiah 46:4

God Given Eye

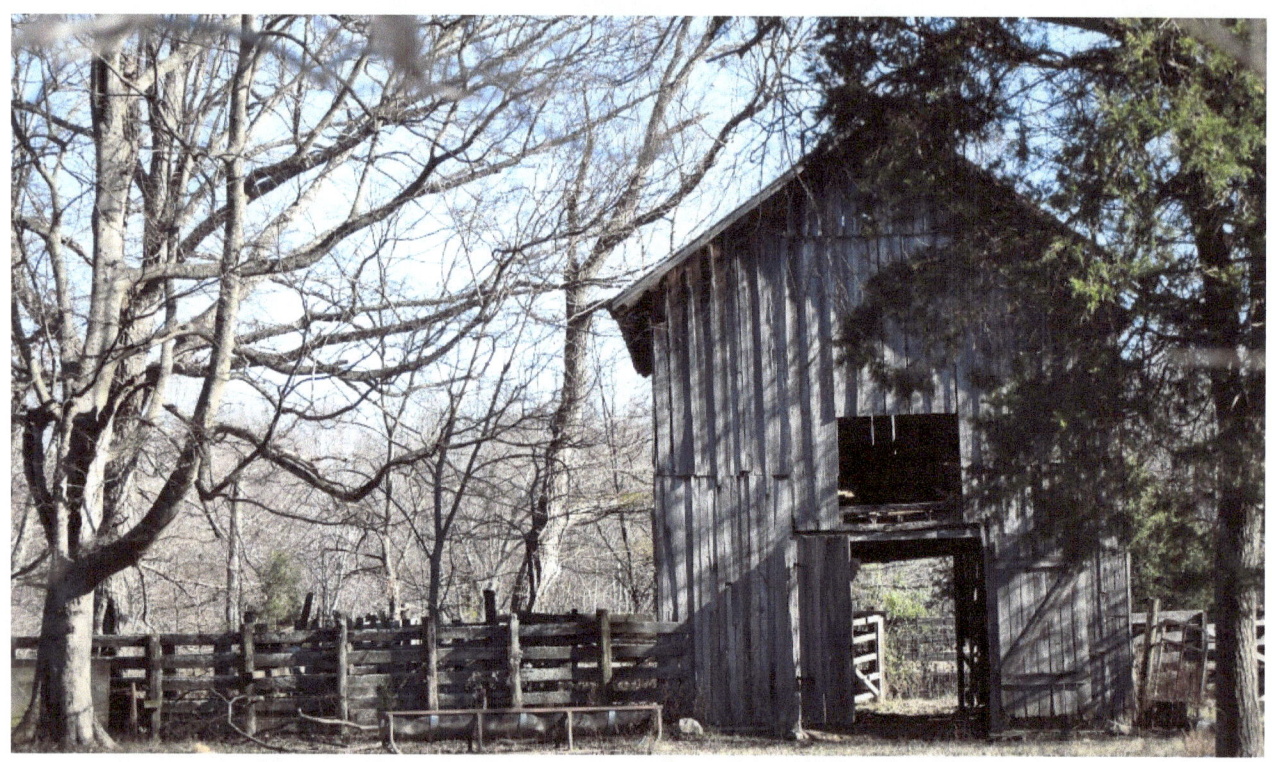

Honor the Lord with your wealth, with the firstfruits of all your crops; then your barns will be filled to overflowing, and your vats will brim over with new wine.

 Proverbs 3:9-10

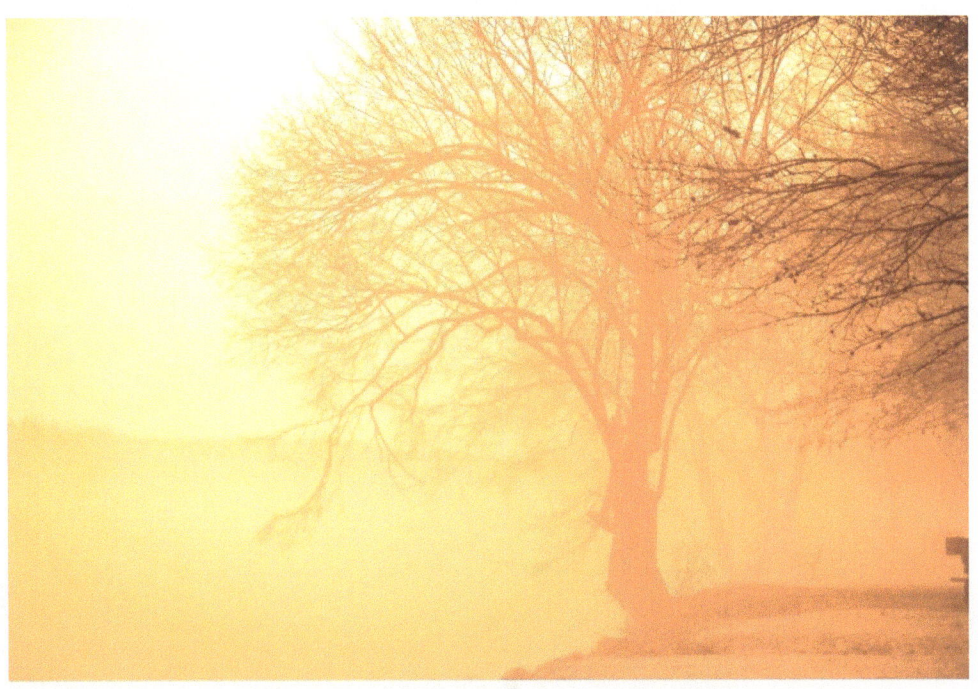

Why, you do not even know what will happen tomorrow. What is your life? You are a mist that appears for a little while and then vanishes.
James 4:14

Commit your way to the Lord;
trust in him and he will do this:
He will make your righteous reward shine like the dawn, your vindication like the noonday sun.

Psalm 37:5-6

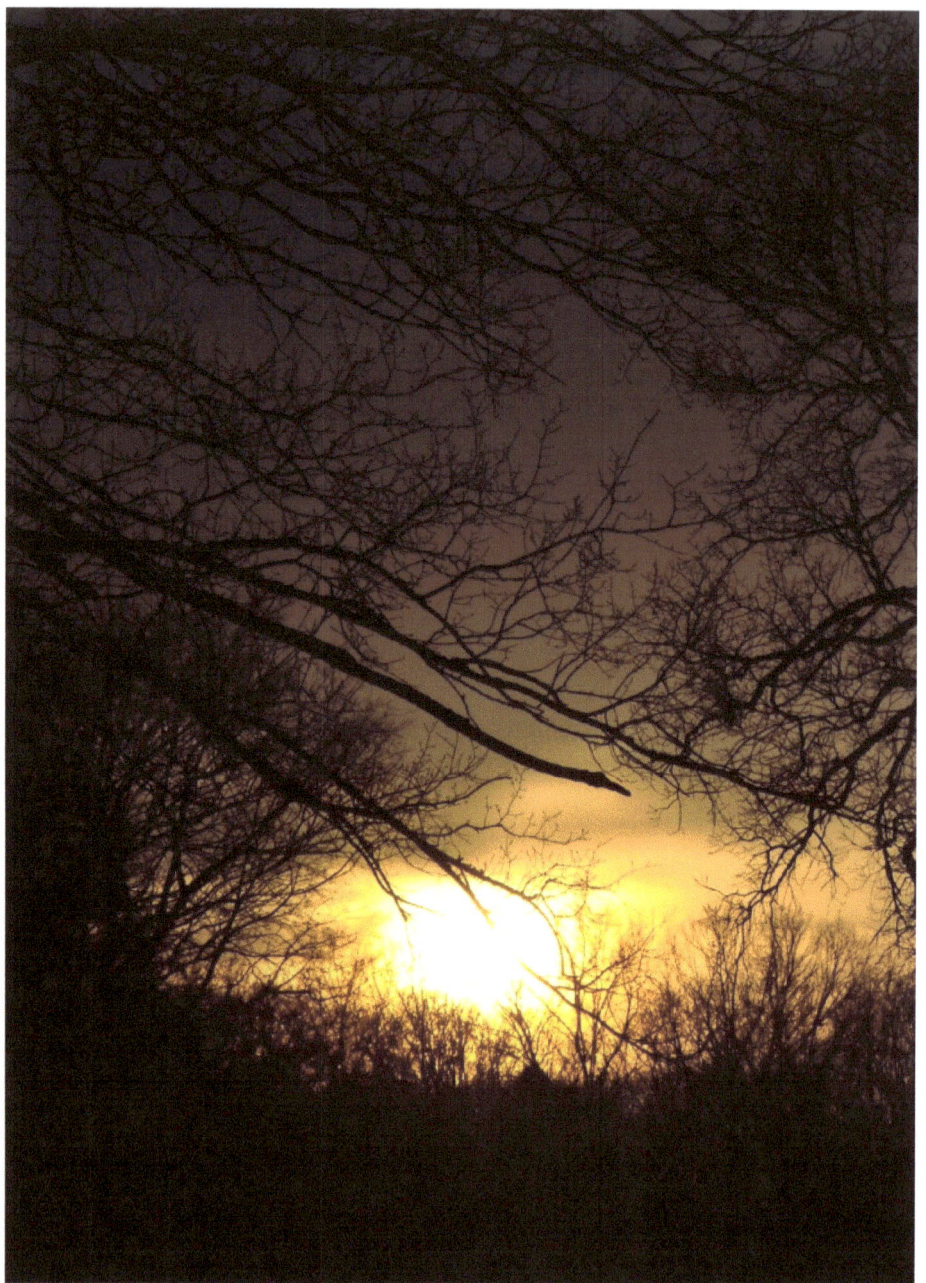

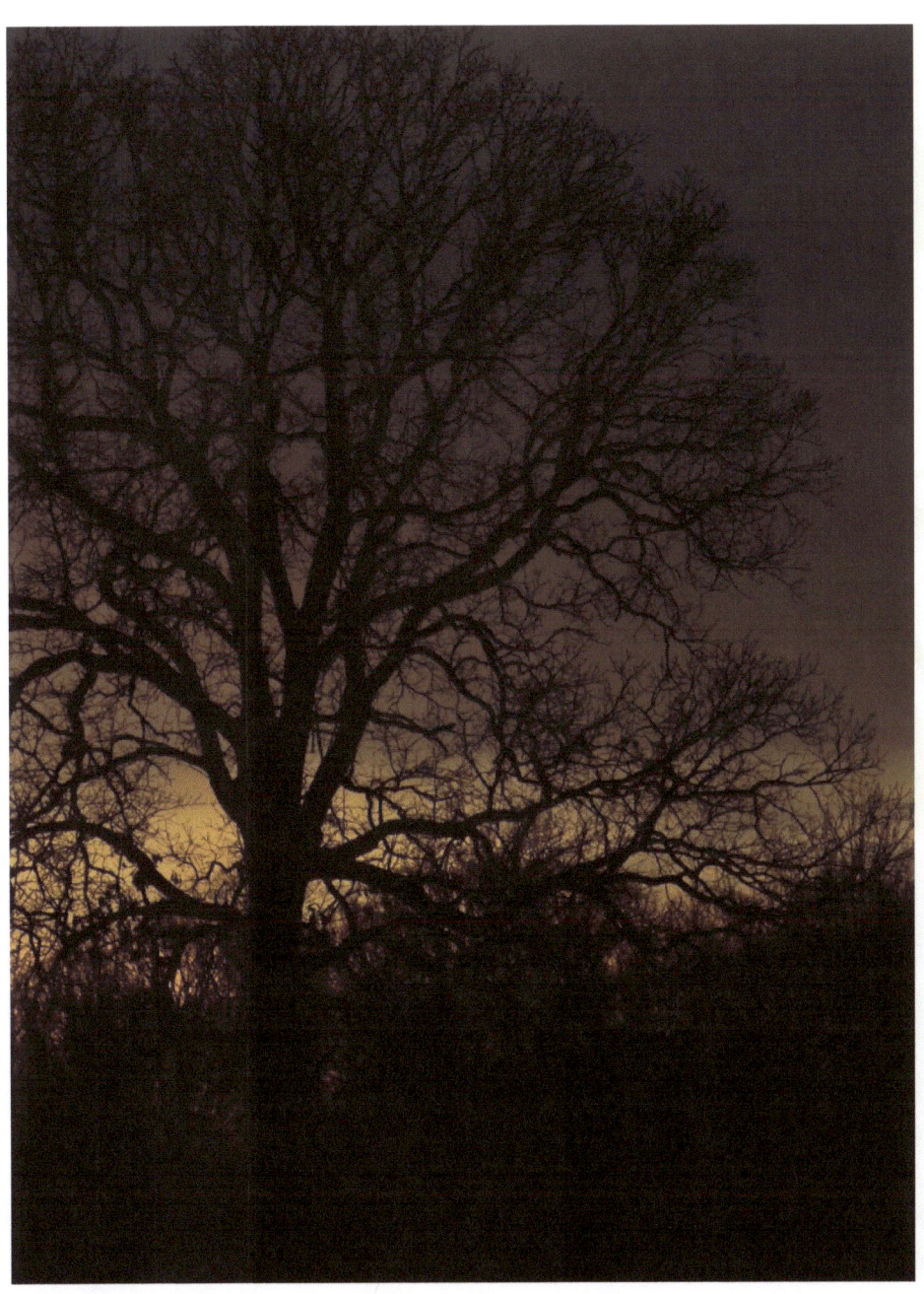

He says, "Be still, and know that I am God; I will be exalted among the nations, I will be exalted in the earth."

Psalm 46:10

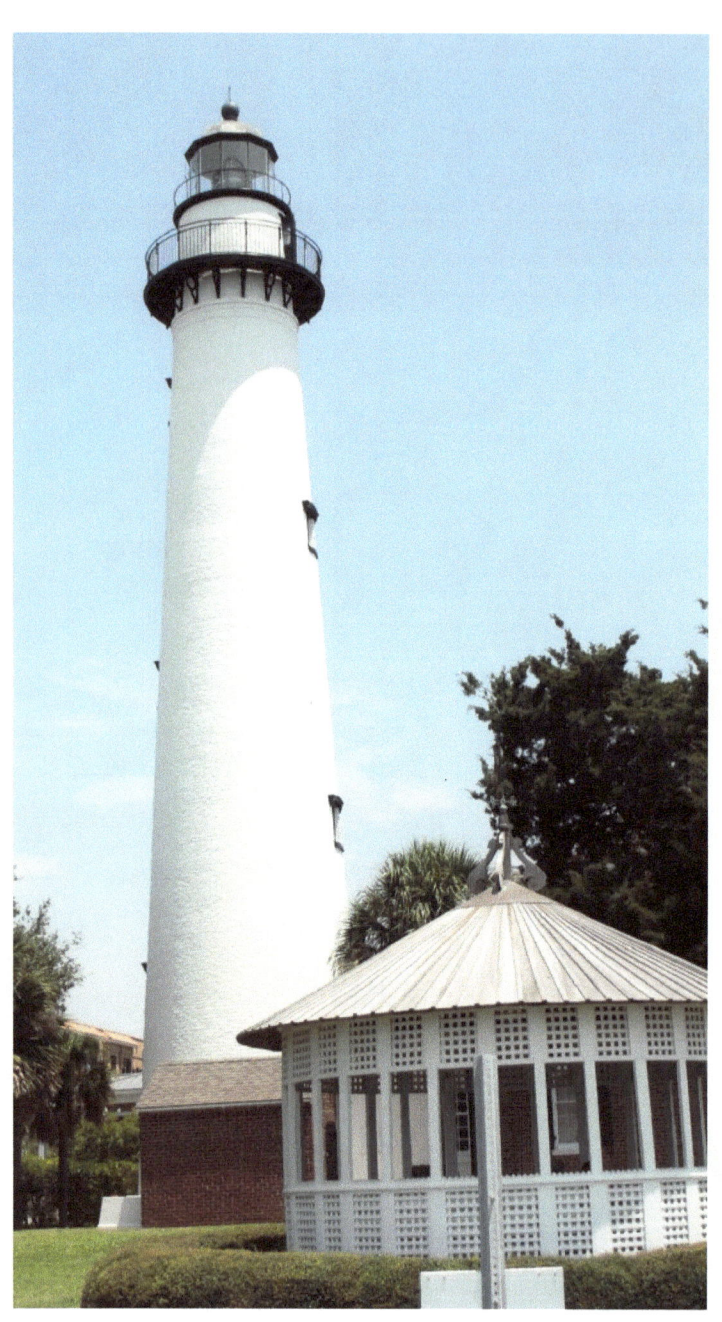

When Jesus spoke again to the people, he said, "I am the light of the world. Whoever follows me will never walk in darkness, but will have the light of life.

John 8:12

God Given Eye

Ask and it will be given to you; seek and you will find; knock and the door will be opened to you.

Matthew 7:7

God Given Eye

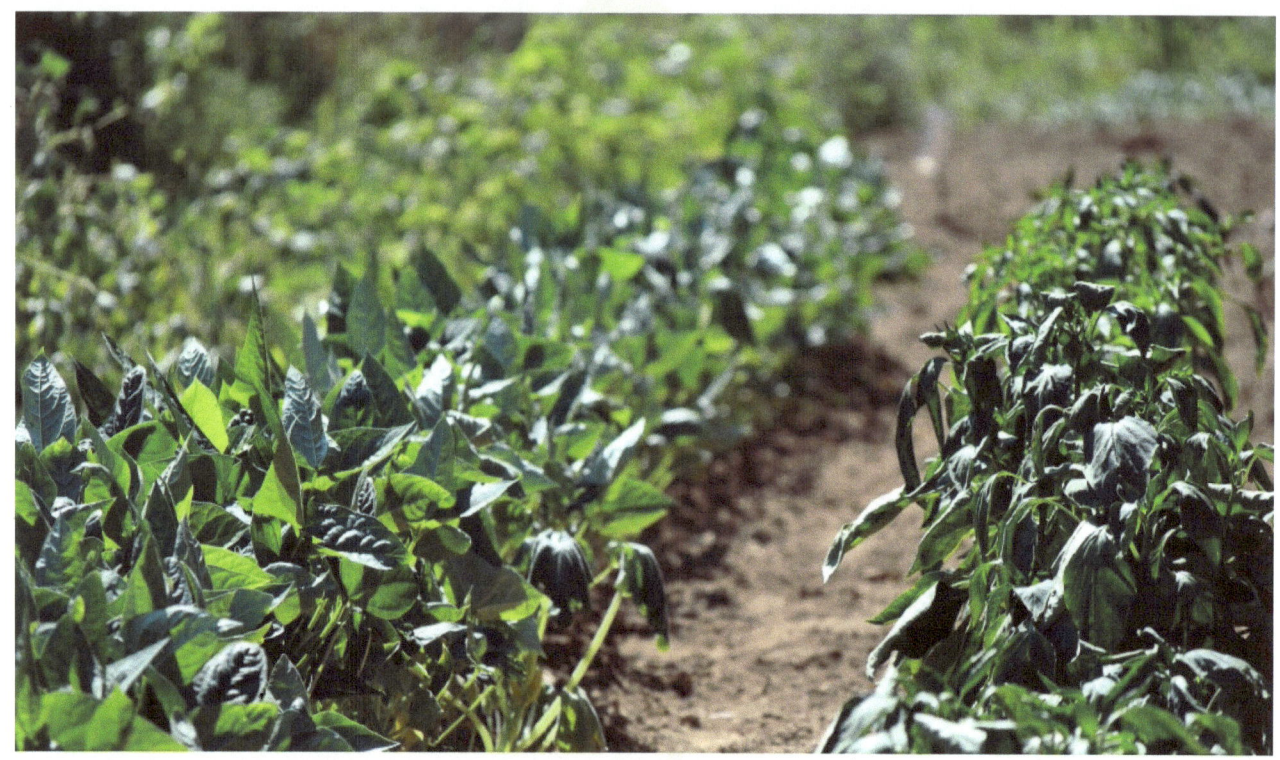

Those who sow with tears will reap with songs of joy.
Those who go out weeping, carrying seed to sow,
will return with songs of joy, carrying sheaves with them.
 Psalm 126:5-6

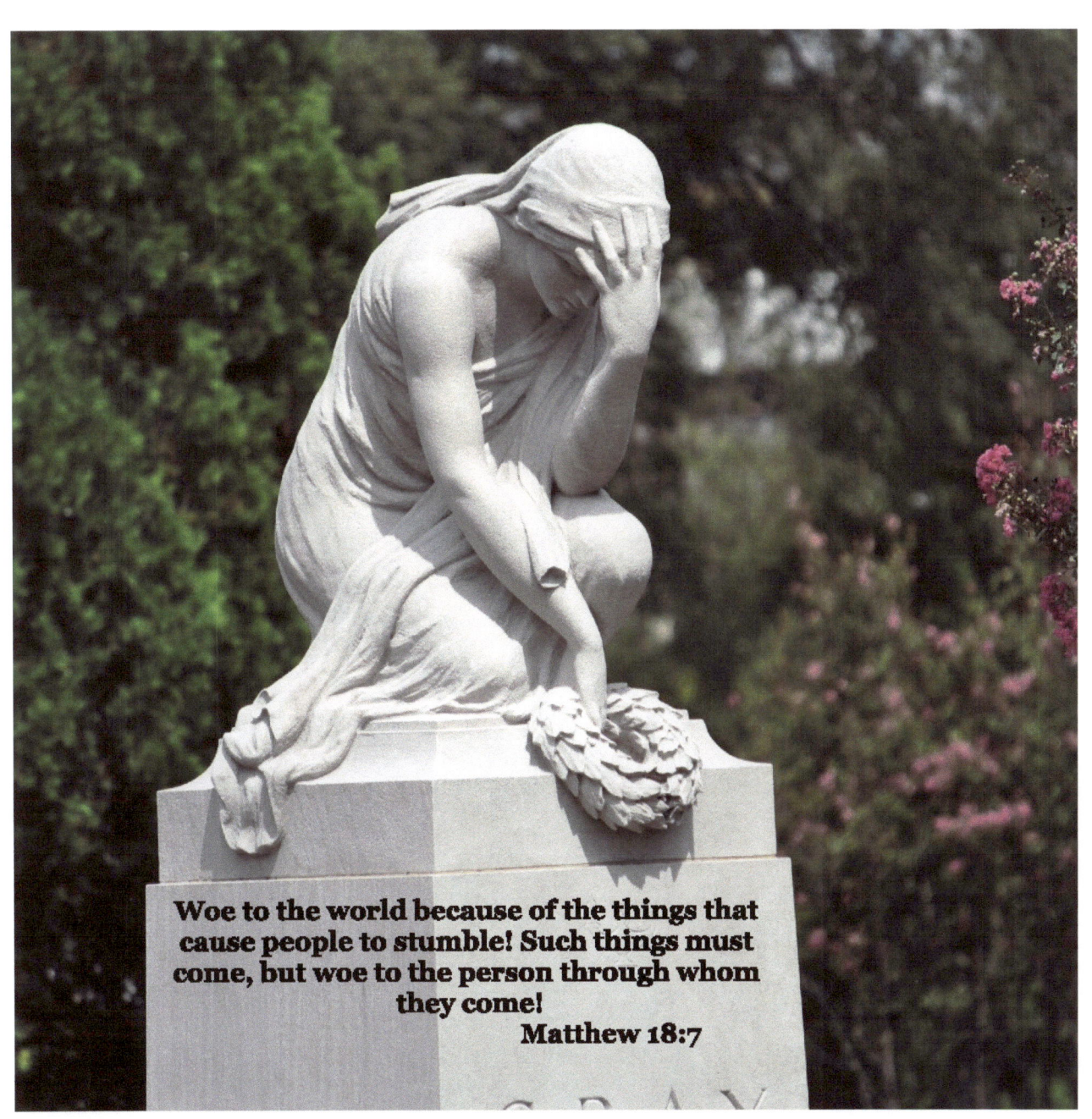

The Lord will send a blessing on your barns and on everything you put your hand to. The Lord your God will bless you in the land he is giving you.
Deuteronomy 28:8

God Given Eye

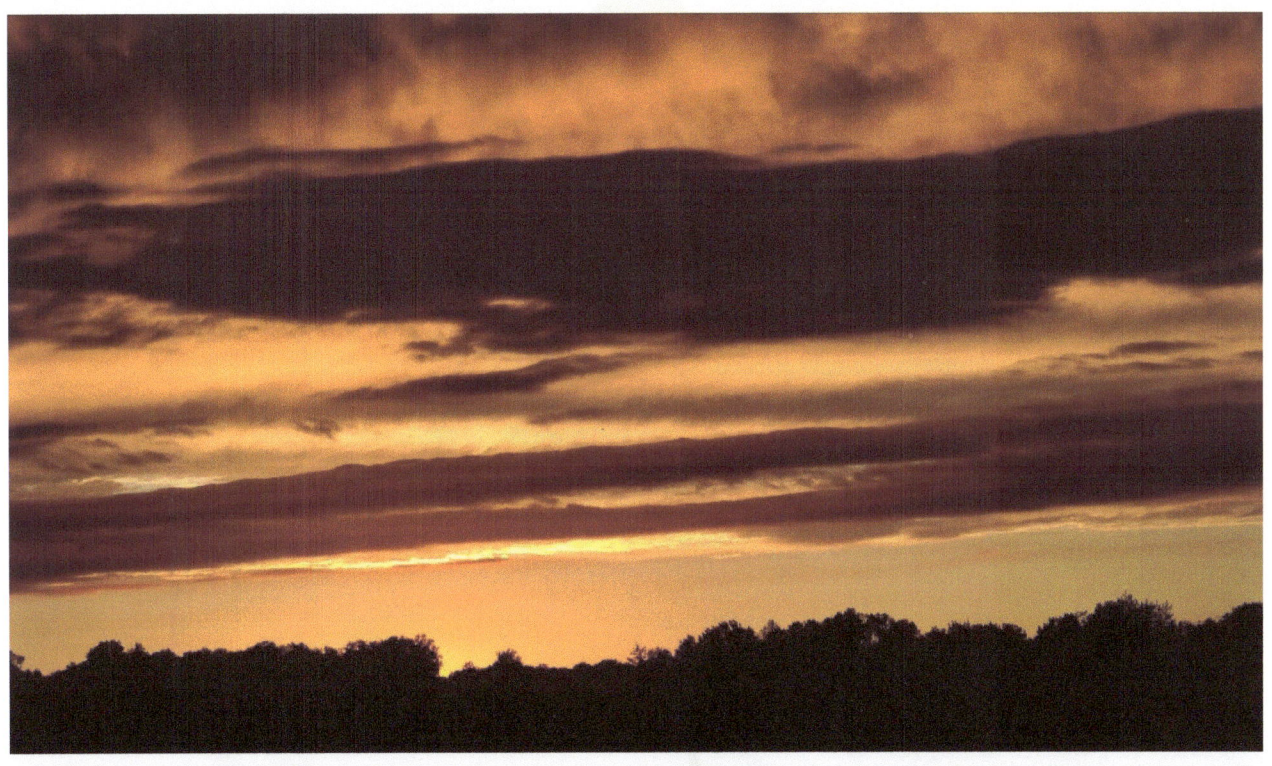

For the Lord God is a sun and shield; the Lord bestows favor and honor;
no good thing does he withhold from those whose walk is blameless.
Psalm 84:11

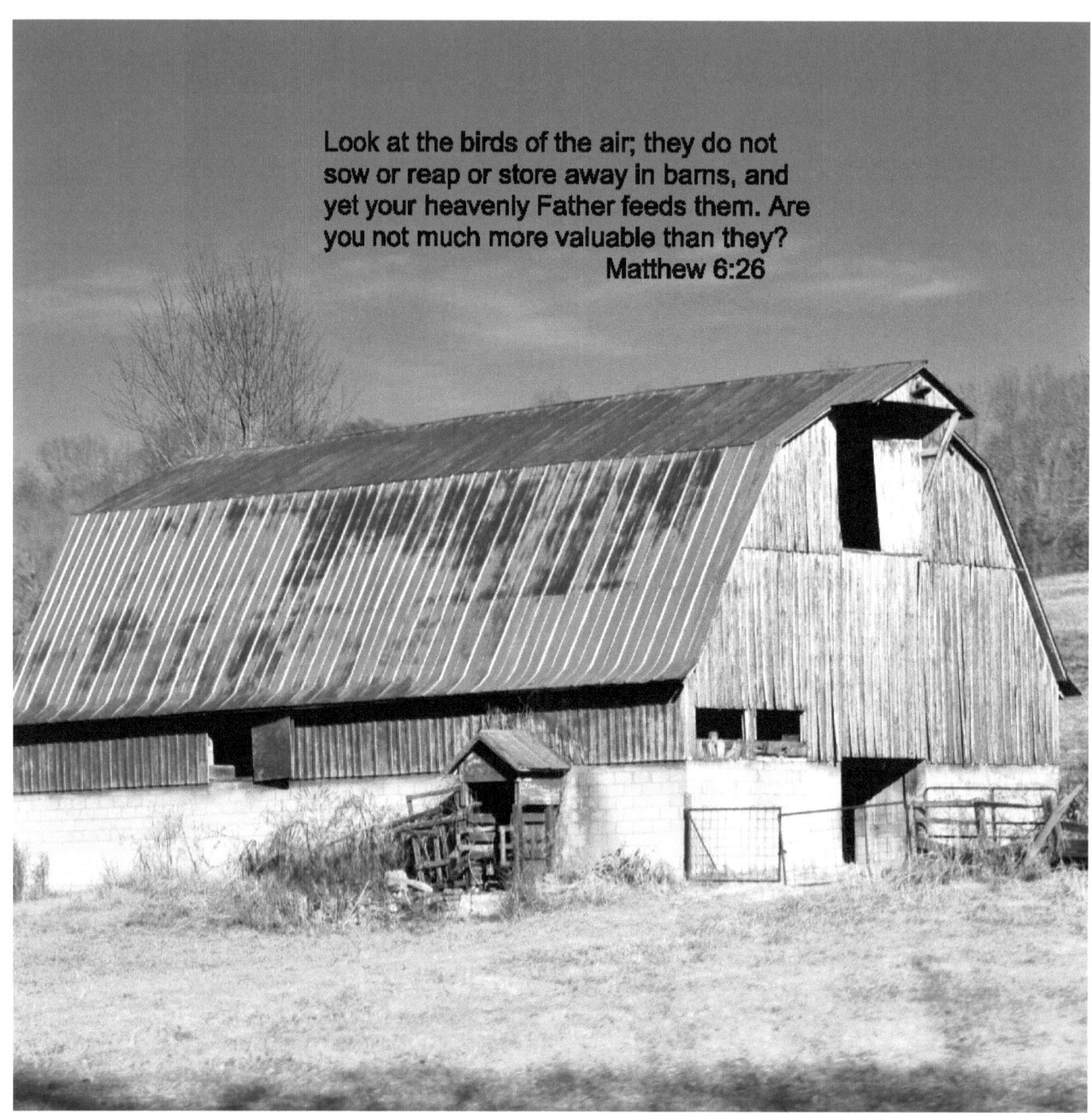

Jesus turned and saw her. "Take heart, daughter," he said, "your faith has healed you." And the woman was healed at that moment.
 Matthew 9:22

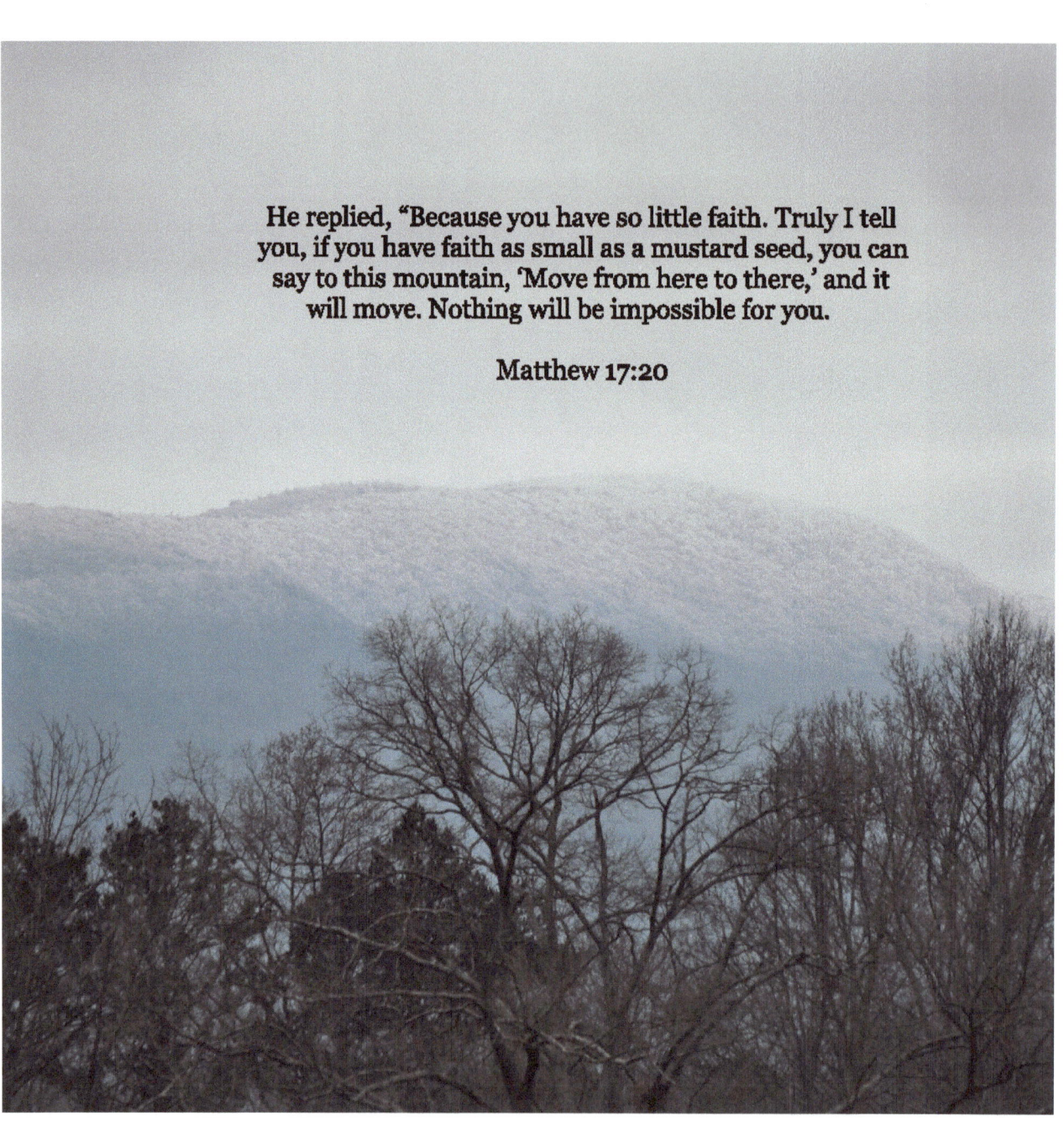

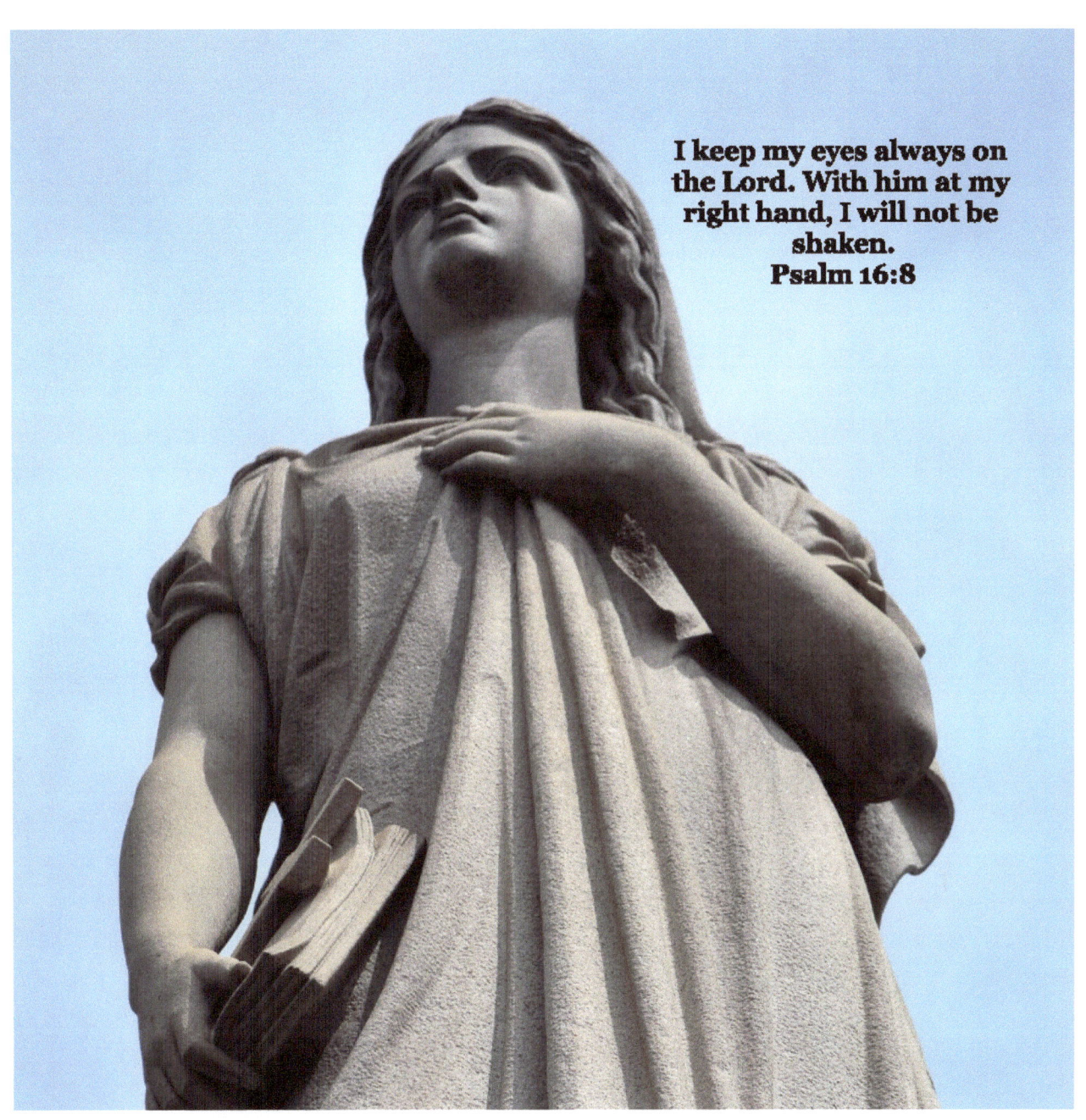

God Given Eye

 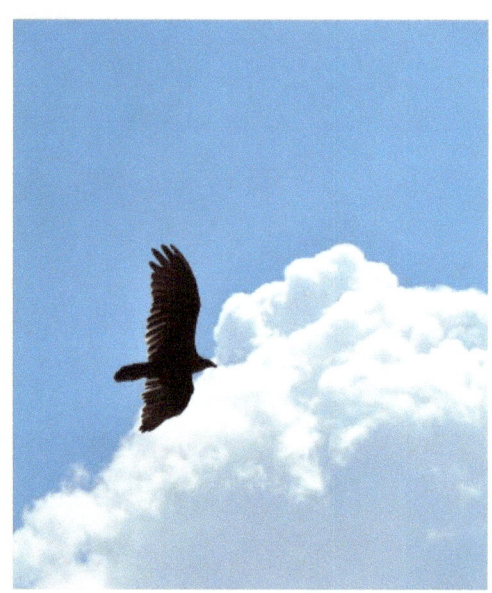

But those who hope in the Lord will renew their strength.
They will soar on wings like eagles;
they will run and not grow weary,
they will walk and not be faint.
Isaiah 40:31

God Given Eye

"Come now, let us settle the matter," says the Lord.
"Though your sins are like scarlet, they shall be as white as snow;
though they are red as crimson, they shall be like wool.
Isaiah 1:18

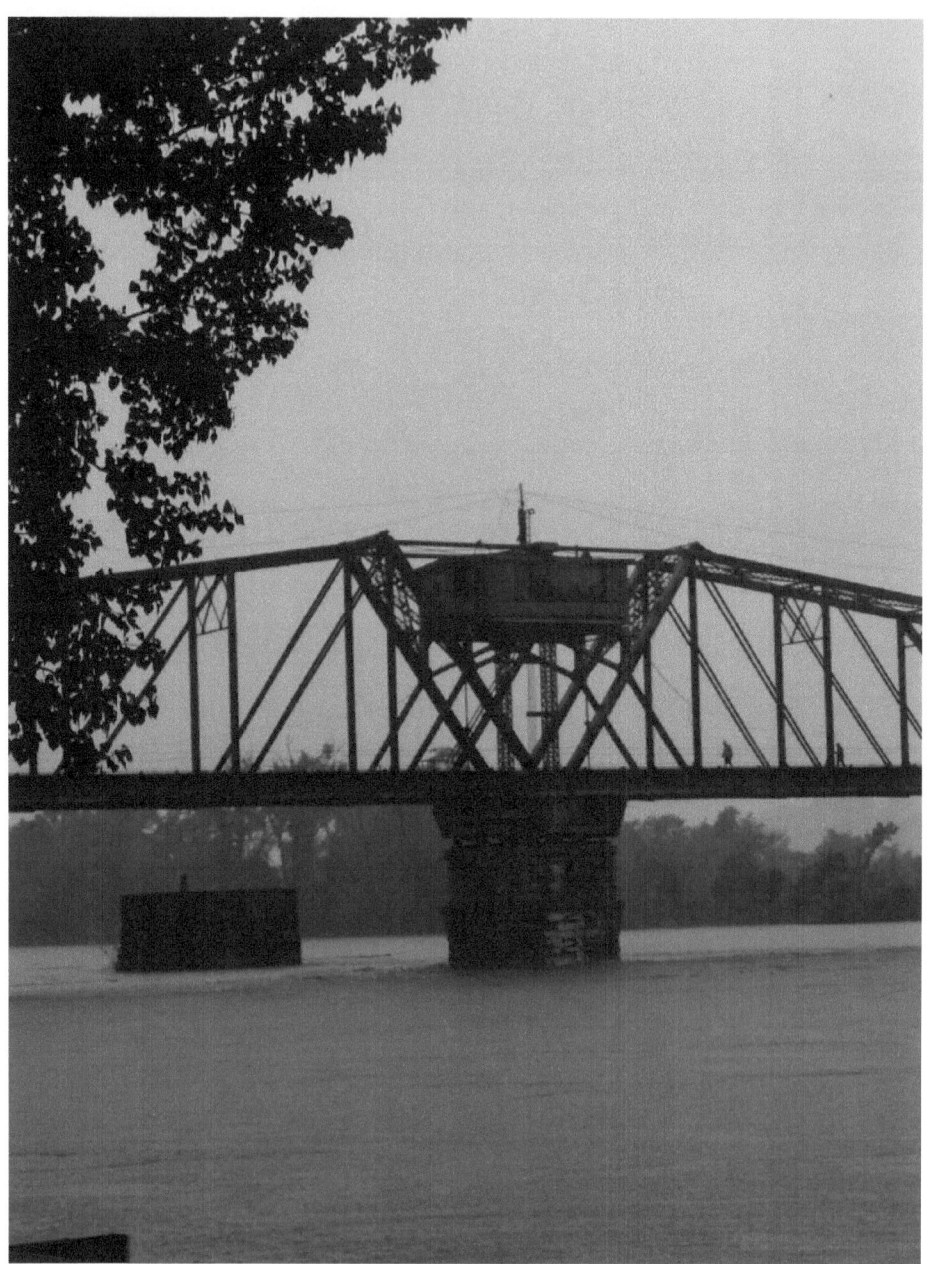

They are like a man building a house, who dug down deep and laid the foundation on rock. When a flood came, the torrent struck that house but could not shake it, because it was well built.

Luke 6:48

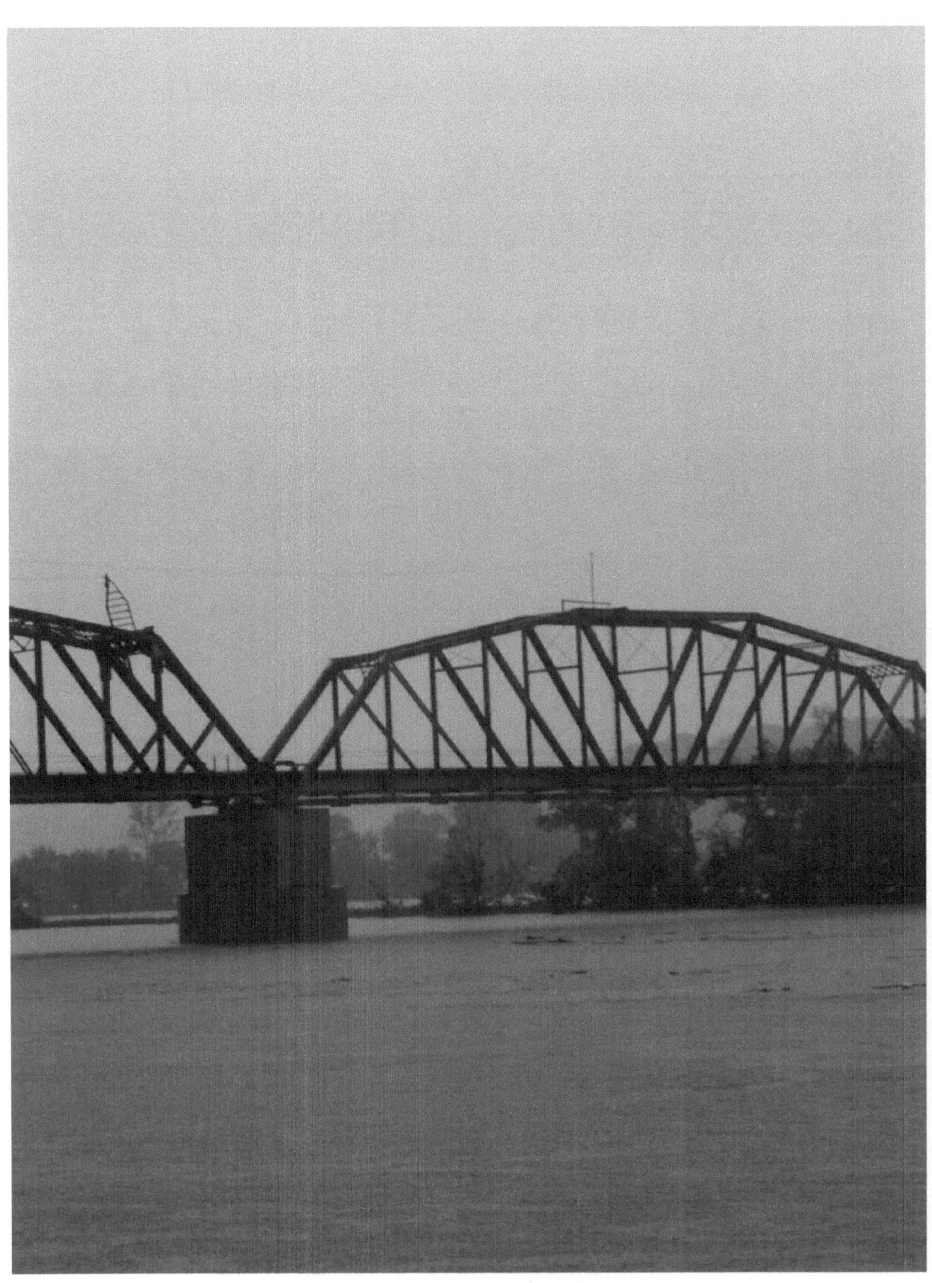

Bring the whole tithe into the storehouse, that there may be food in my house. Test me in this," says the Lord Almighty, "and see if I will not throw open the floodgates of heaven and pour out so much blessing that there will not be room enough to store it.

Malachi 3:10

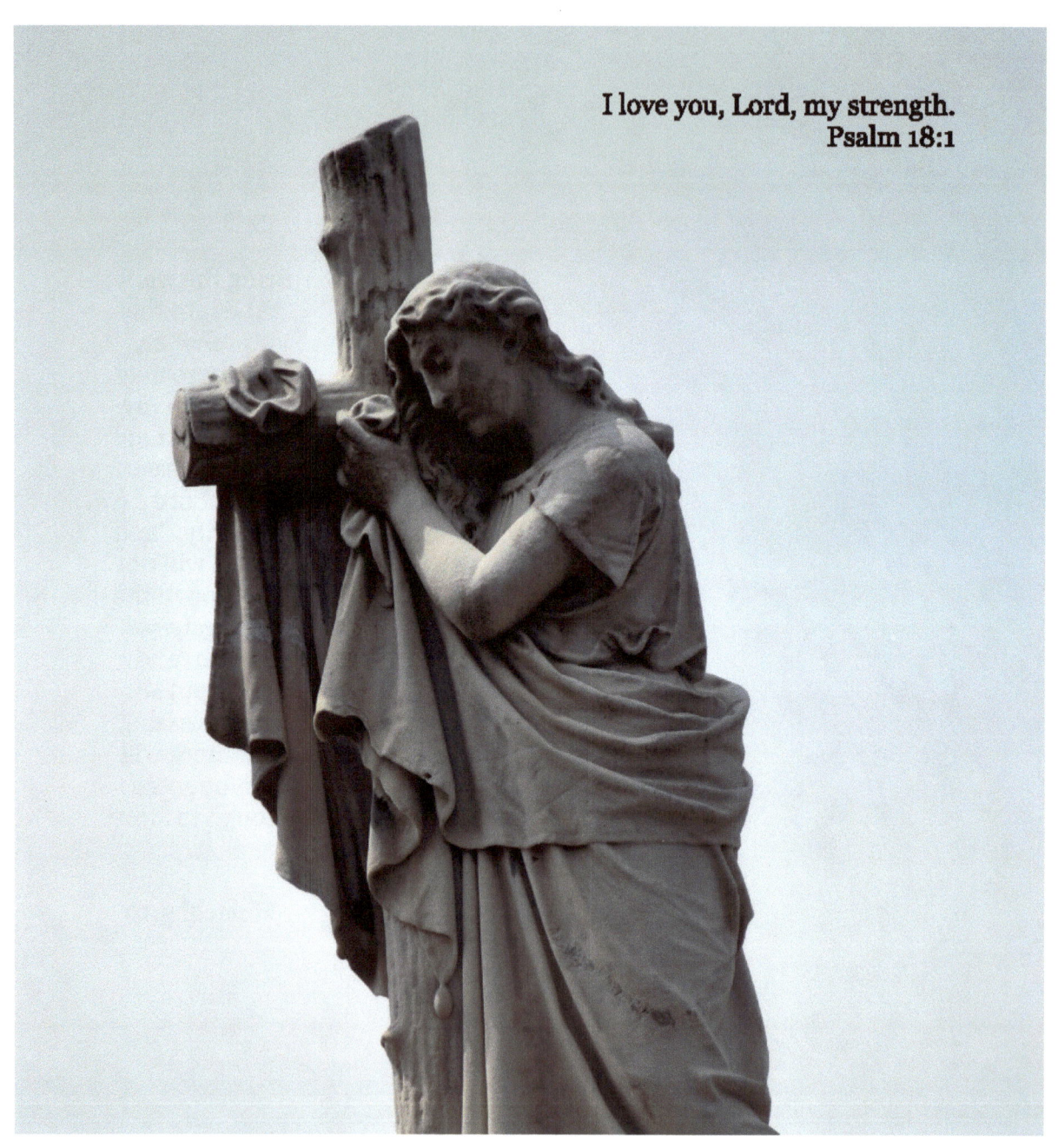

I love you, Lord, my strength.
Psalm 18:1

God Given Eye

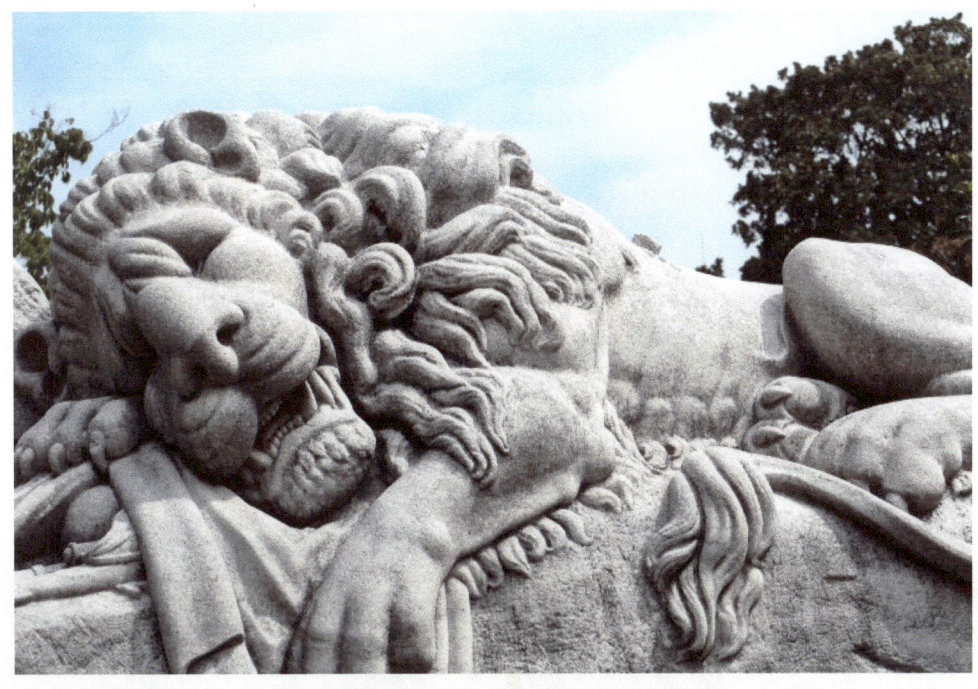

The lions may grow weak and hungry, but those who seek the Lord lack no good thing.
 Psalm 34:10

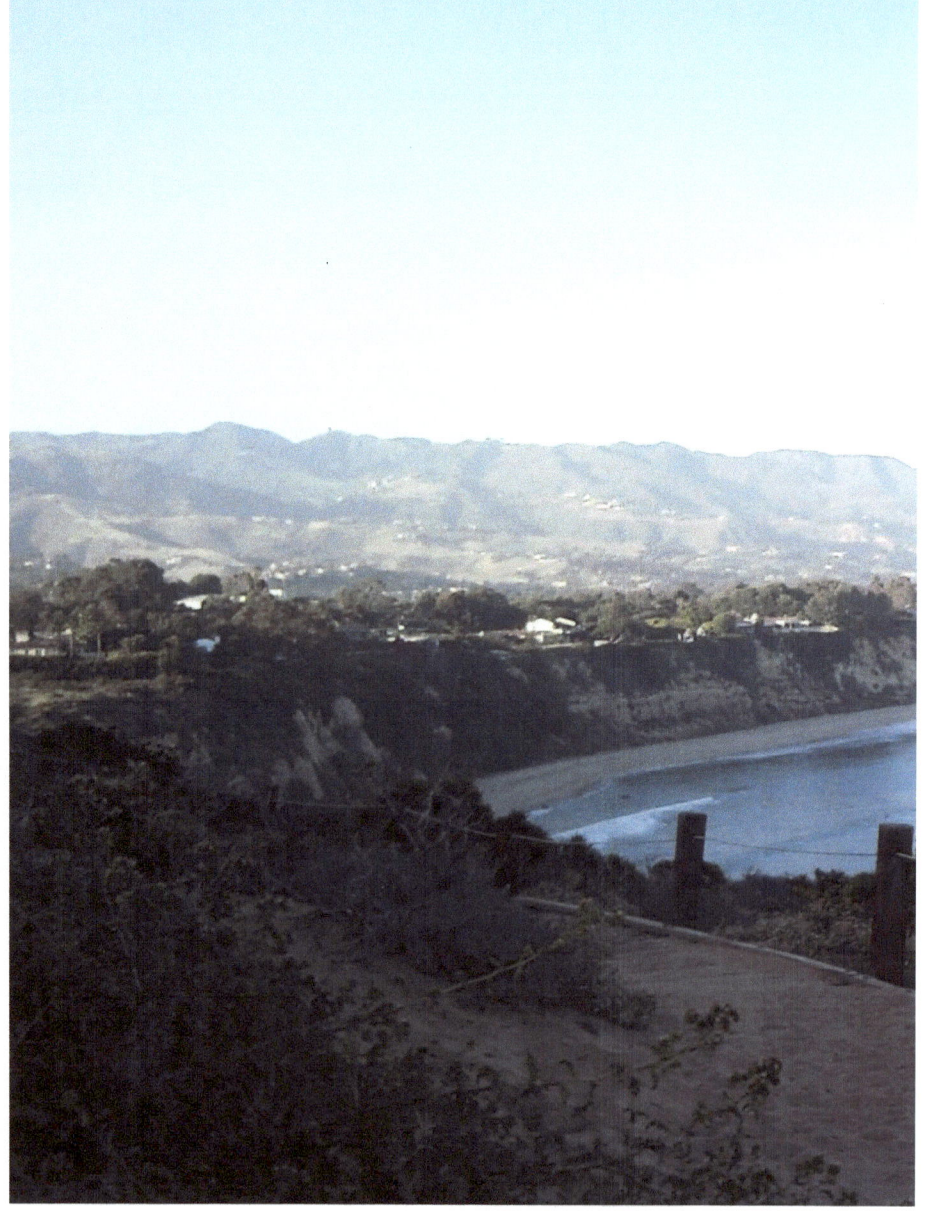

Have faith in God," Jesus answered. "Truly I tell you, if anyone says to this mountain, 'Go, throw yourself into the sea,' and does not doubt in their heart but believes that what they say will happen, it will be done for them.

Mark 11:22-23

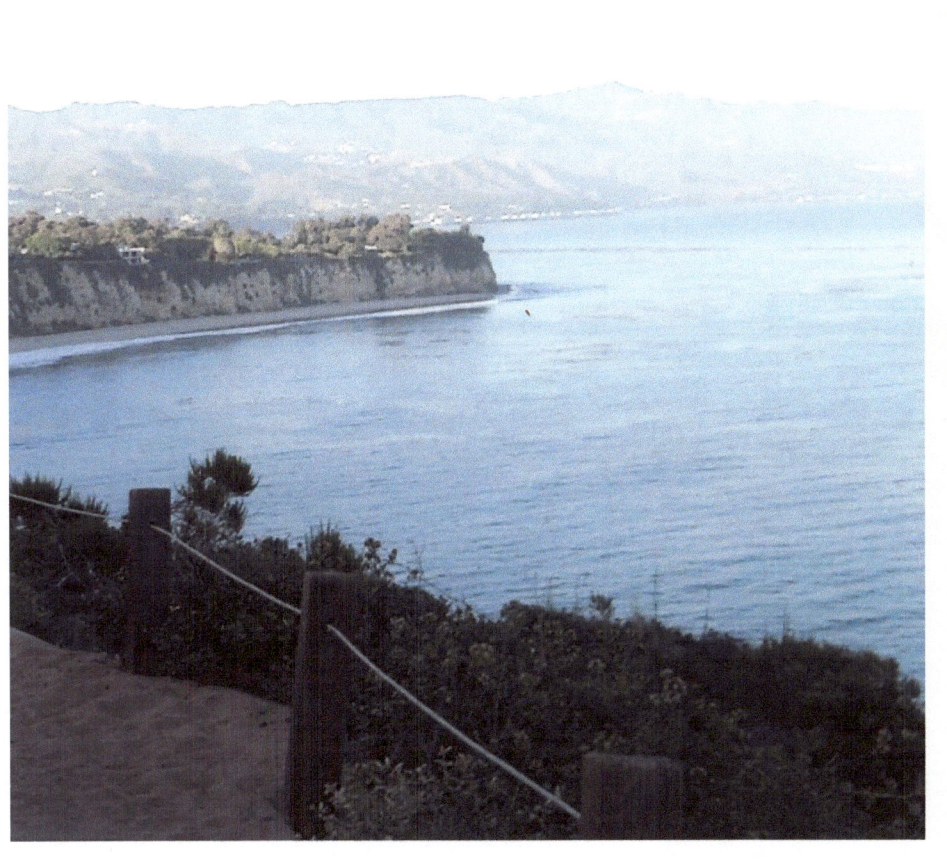

God is our refuge and strength, an ever-present help in trouble. Therefore we will not fear, though the earth give way and the mountains fall into the heart of the sea, though its waters roar and foam and the mountains quake with their surging.

Psalm 46:1-3

In their hearts humans plan their course, but the Lord establishes their steps.

Proverbs 16:9

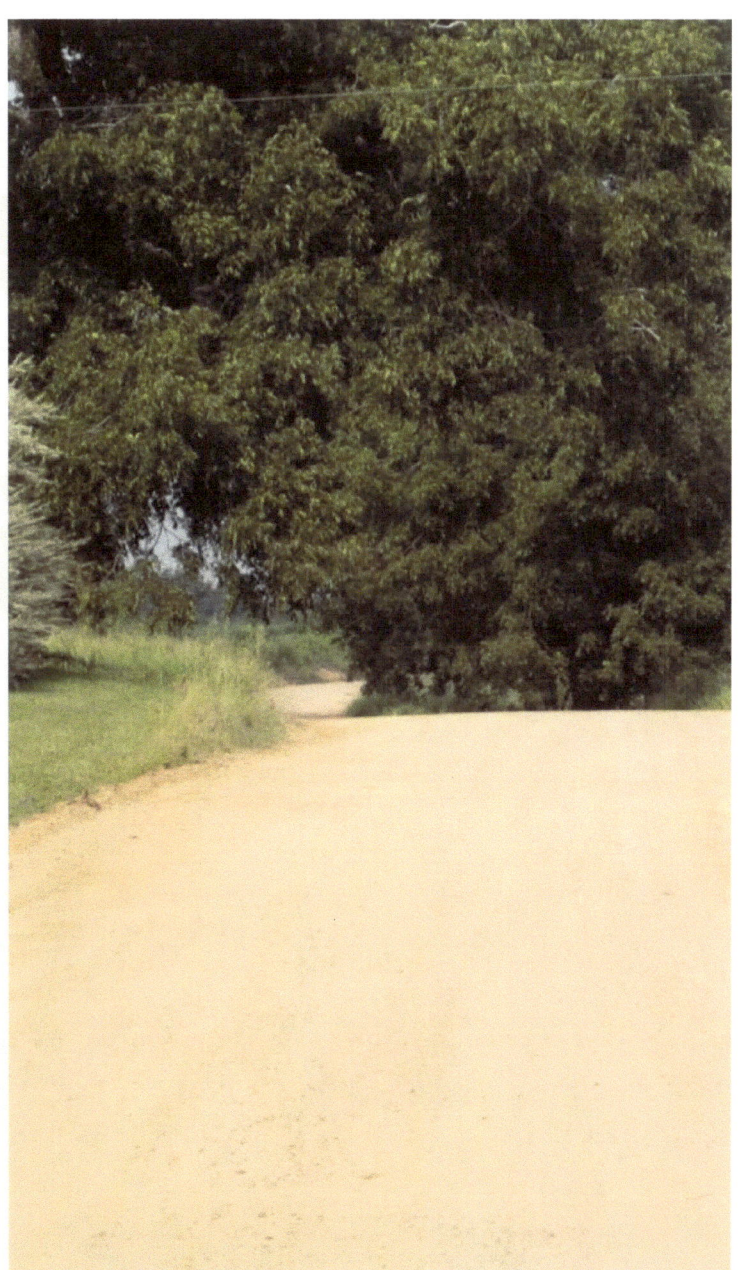

Trust in the Lord
with all your heart
and lean not on your
own understanding;
in all your ways
submit to him,
and he will make
your paths straight.

Proverbs 3:5-6

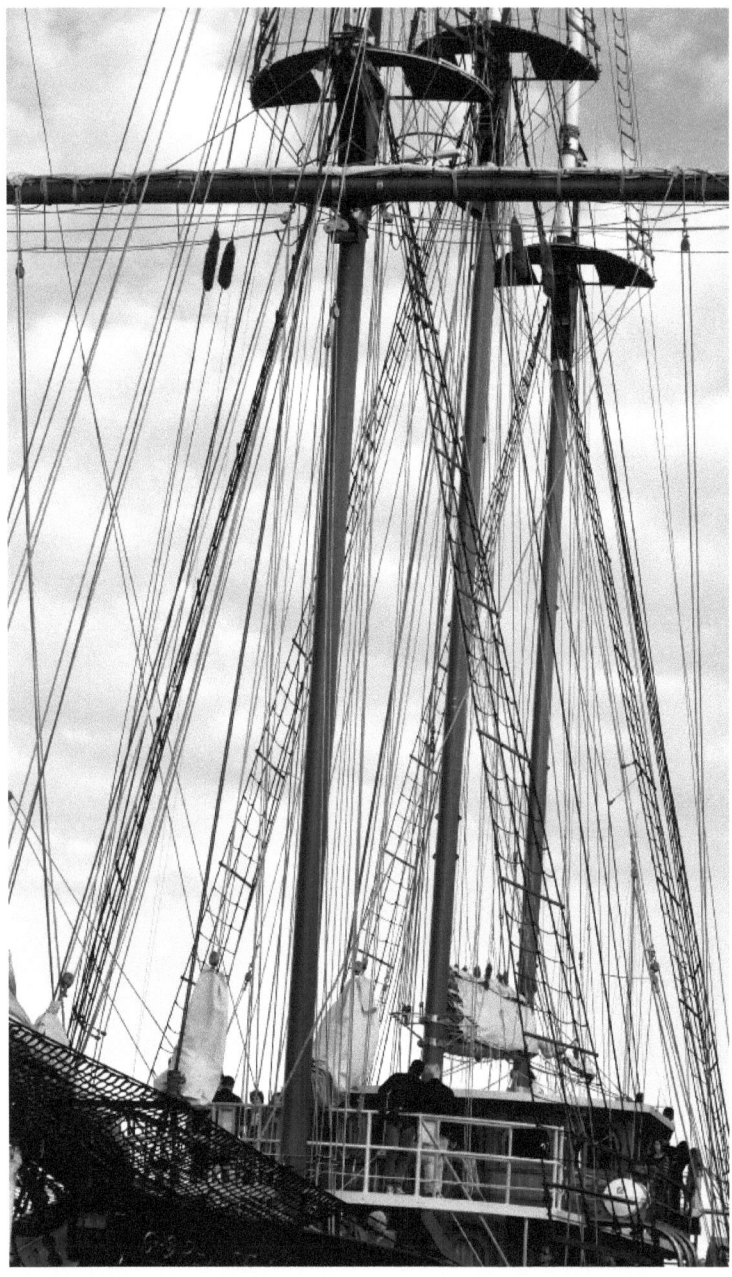

When we put bits into the mouths of horses to make them obey us, we can turn the whole animal. Or take ships as an example. Although they are so large and are driven by strong winds, they are steered by a very small rudder wherever the pilot wants to go. Likewise, the tongue is a small part of the body, but it makes great boasts. Consider what a great forest is set on fire by a small spark.

James 3:3-5

God Given Eye

But blessed is the one who trusts in the Lord, whose confidence is in him.
They will be like a tree planted by the water that sends out its roots by the stream.
It does not fear when heat comes; its leaves are always green.
It has no worries in a year of drought and never fails to bear fruit.
Jeremiah 17:7-8

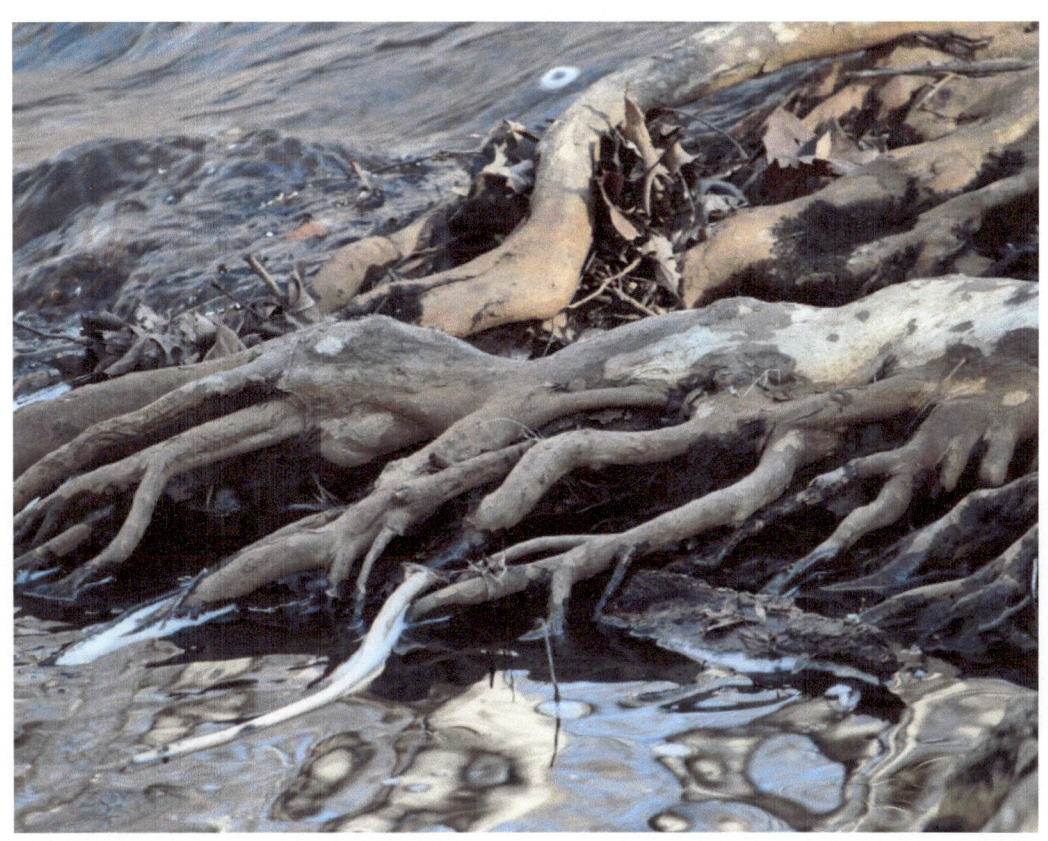

God Given Eye

When anyone hears the word of the kingdom and does not understand it, the evil one comes and snatches away what has been sown in his heart. This is the one on whom seed was sown beside the road. The one on whom seed was sown on the rocky places, this is the man who hears the word and immediately receives it with joy; yet he has no firm root in himself, but is only temporary, and when affliction or persecution arises because of the word, immediately he falls away.

Matthew 13:19-21

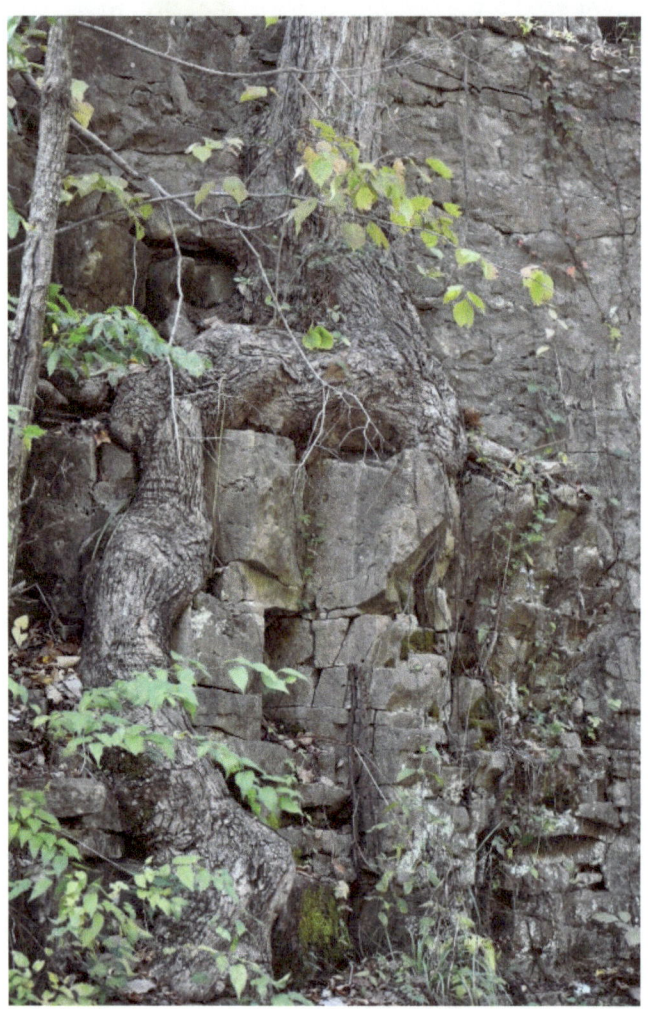

But when you pray, go into your room, close the door and pray to your Father, who is unseen. Then your Father, who sees what is done in secret, will reward you.

Matthew 6:6

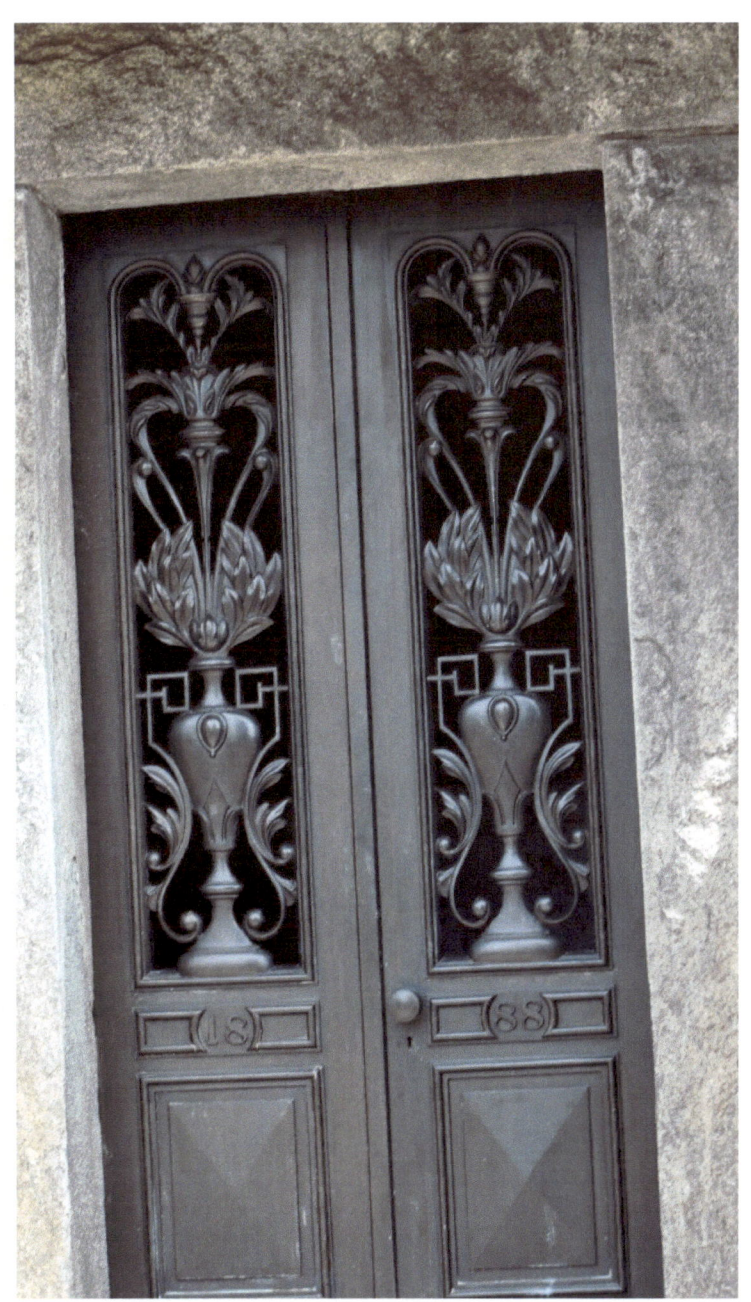

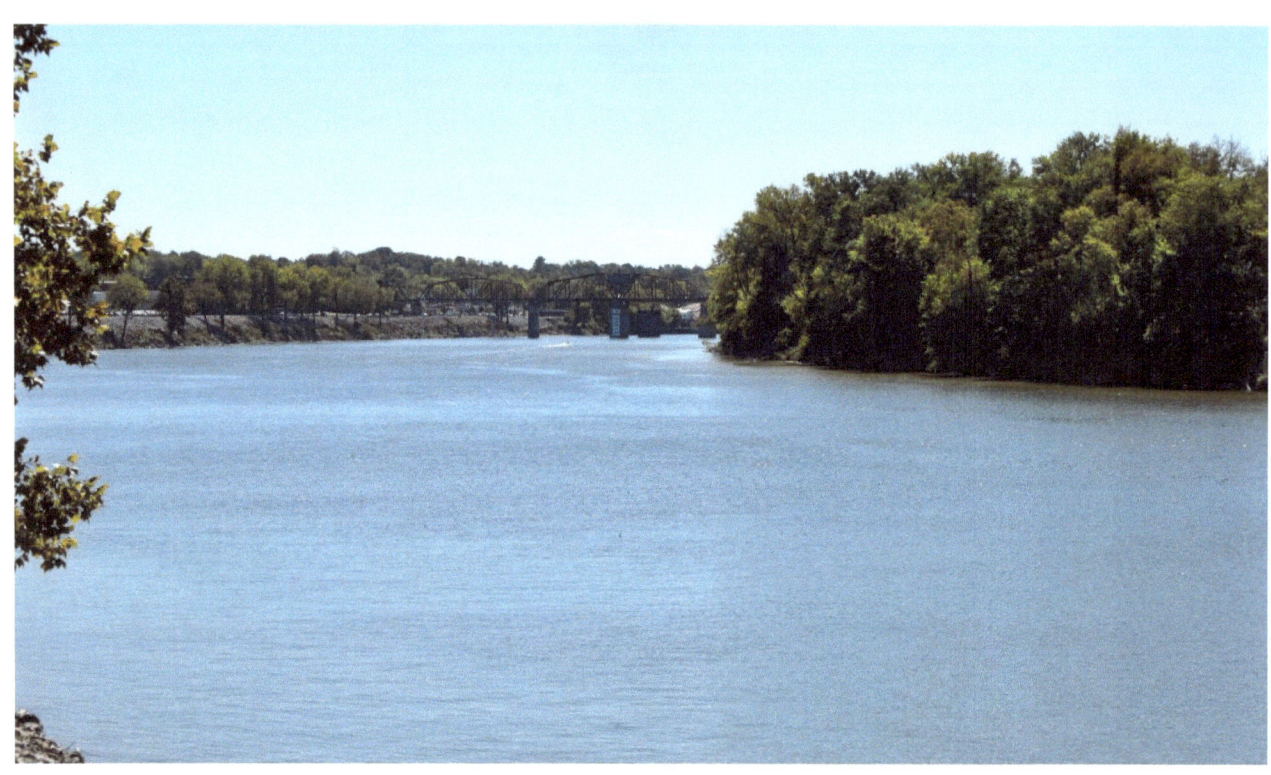

Peter replied, "Repent and be baptized, every one of you, in the name of Jesus Christ for the forgiveness of your sins. And you will receive the gift of the Holy Spirit.

Acts 2:38

God Given Eye

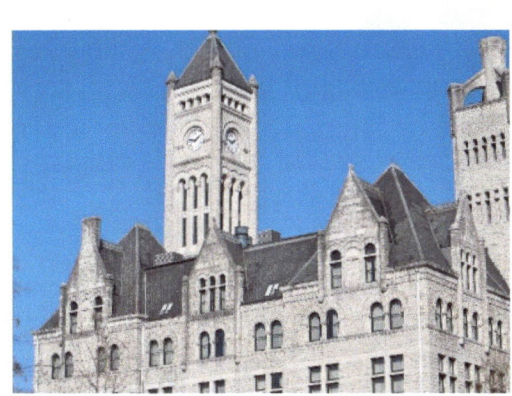

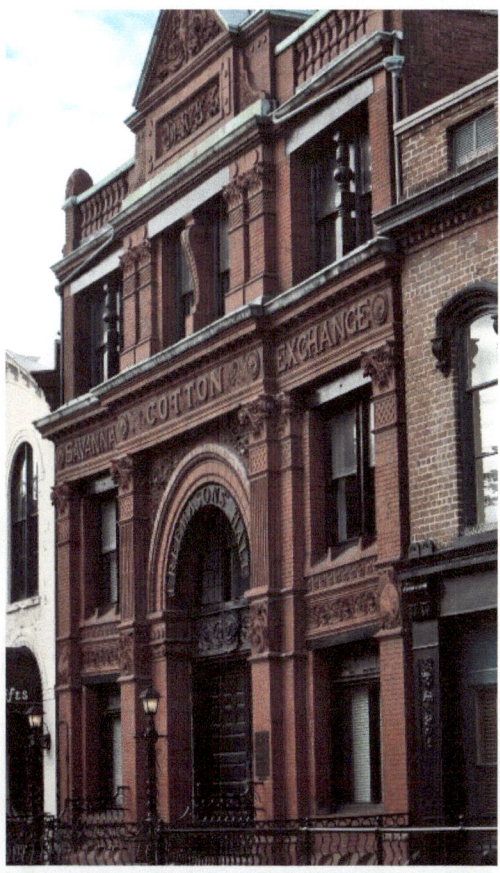

As Jesus was leaving the temple, one of his disciples said to him, "Look, Teacher! What massive stones! What magnificent buildings!" "Do you see all these great buildings?" replied Jesus. "Not one stone here will be left on another; every one will be thrown down."
Mark 13:1-2

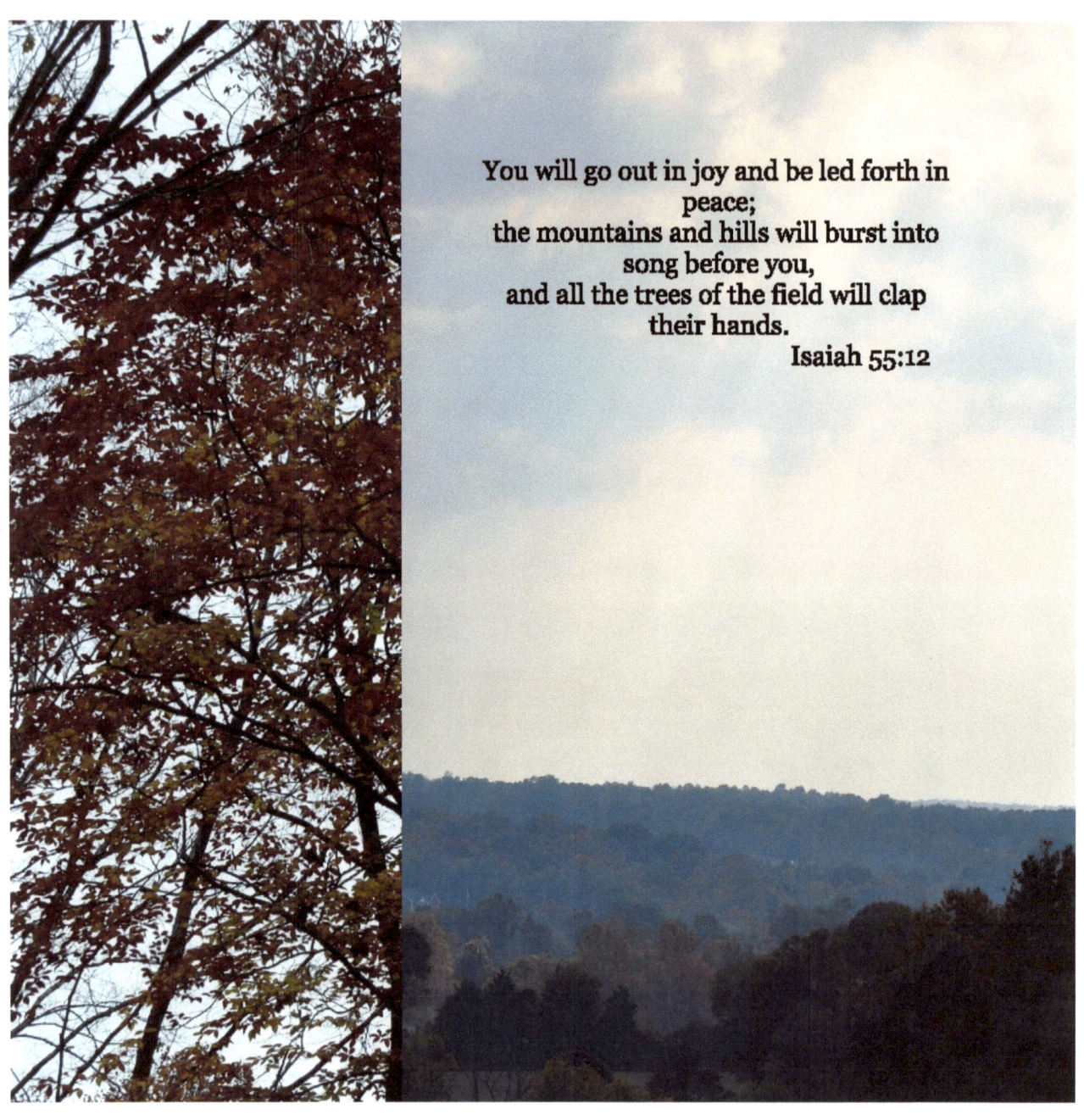

You will go out in joy and be led forth in peace;
the mountains and hills will burst into song before you,
and all the trees of the field will clap their hands.
Isaiah 55:12

Are not two sparrows sold for a penny? Yet not one of them will fall to the ground outside your Father's care. And even the very hairs of your head are all numbered. So don't be afraid; you are worth more than many sparrows.

Matthew 10:29-31

God Given Eye

 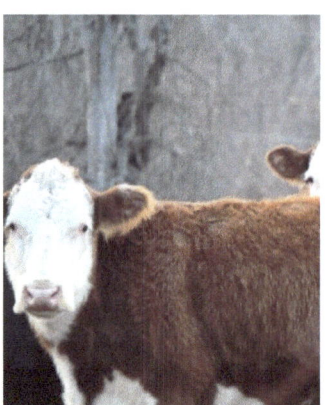

But for you who revere my name, the sun of
righteousness will rise with healing in its rays. And
you will go out and frolic like well-fed calves.
Malachi 4:2

God Given Eye

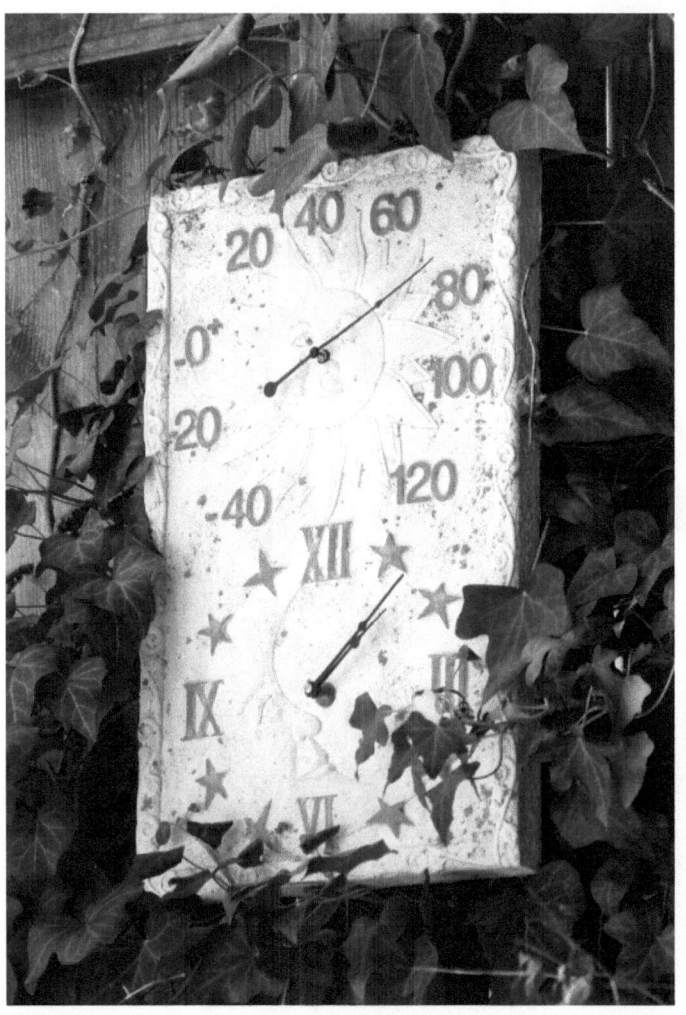

I have seen something else under
the sun:
The race is not to the swift
or the battle to the strong,
nor does food come to the wise
or wealth to the brilliant
or favor to the learned;
but time and chance happen to
them all.

Moreover, no one knows when
their hour will come:
As fish are caught in a cruel net,
or birds are taken in a snare,
so people are trapped by evil
times
that fall unexpectedly upon them.

Ecclesiastes 9:11-12

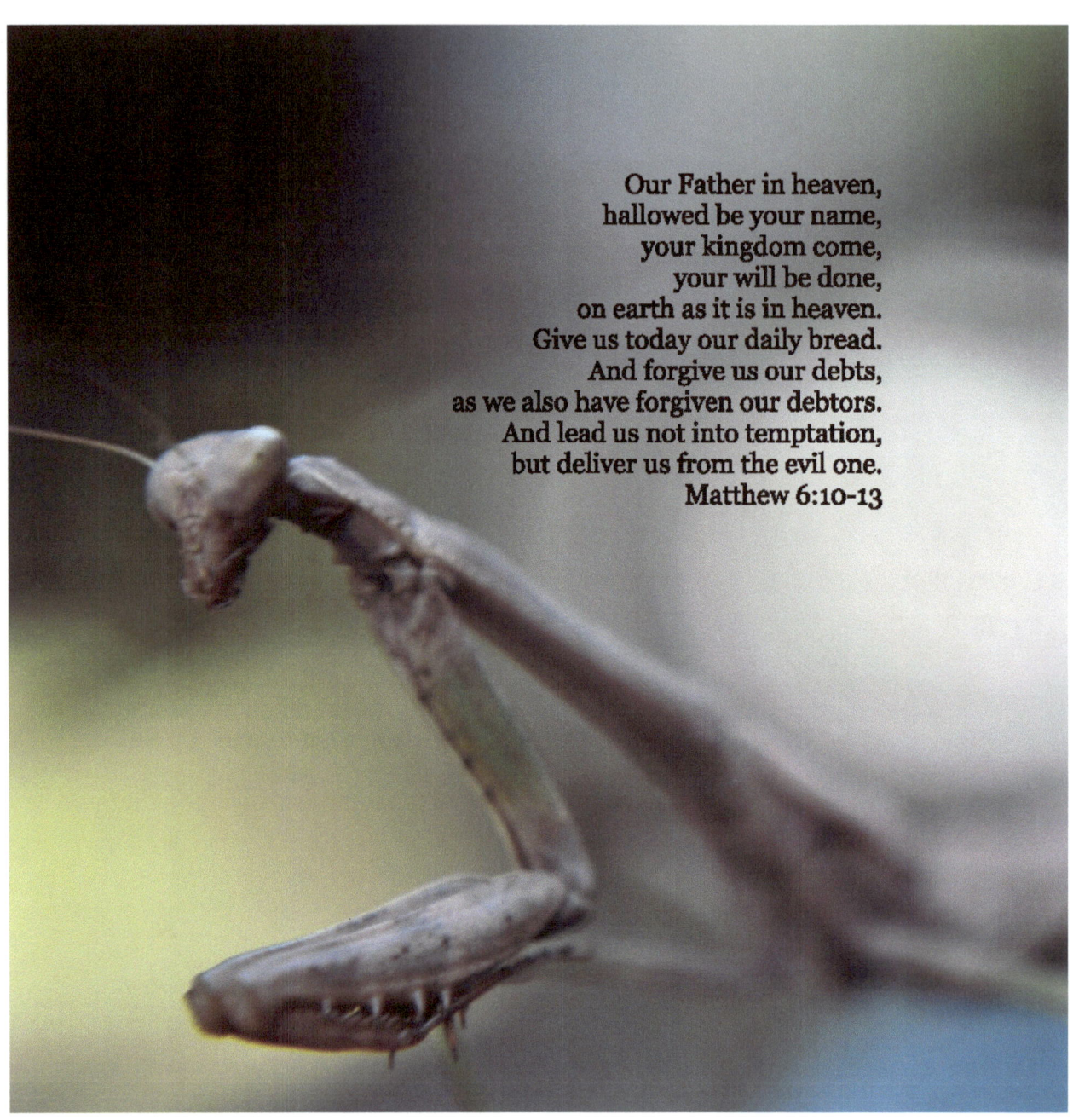

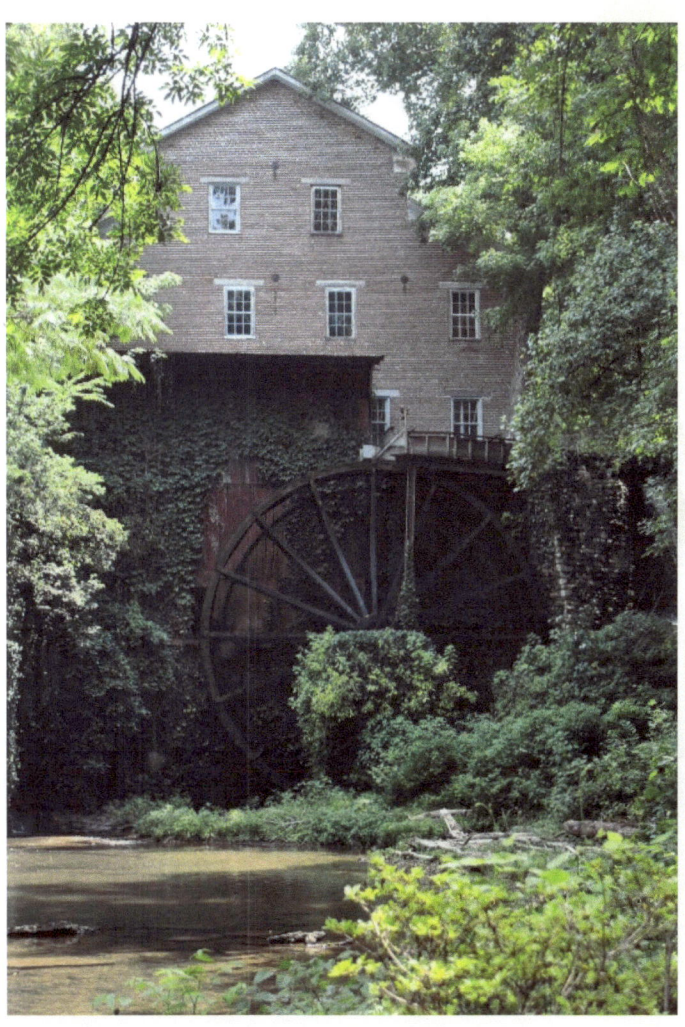

The Lord is my shepherd,
I shall not want.
He makes me lie down in green pastures;
He leads me beside quiet waters.
He restores my soul;
He guides me in the paths of righteousness
For His name's sake.
Even though I walk through the valley of the shadow of death,
I fear no evil, for You are with me;
Your rod and Your staff, they comfort me.
You prepare a table before me in the presence of my enemies;
You have anointed my head with oil;
My cup overflows.
Surely goodness and lovingkindness will follow me all the days of my life,
And I will dwell in the house of the Lord forever.

Psalm 23:1-6

God Given Eye

Whatever you do, work at it with all your heart, as working for the Lord, not for human masters.

Colossians 3:23

No weapon forged against you will prevail, and you will refute every tongue that accuses you.
This is the heritage of the servants of the Lord, and this is their vindication from me," declares the Lord. Isaiah 54:17

"Sir," the woman said, "you have nothing to draw with and the well is deep. Where can you get this living water? Are you greater than our father Jacob, who gave us the well and drank from it himself, as did also his sons and his livestock?"

Jesus answered, "Everyone who drinks this water will be thirsty again, but whoever drinks the water I give them will never thirst. Indeed, the water I give them will become in them a spring of water welling up to eternal life."

John 4:11-14

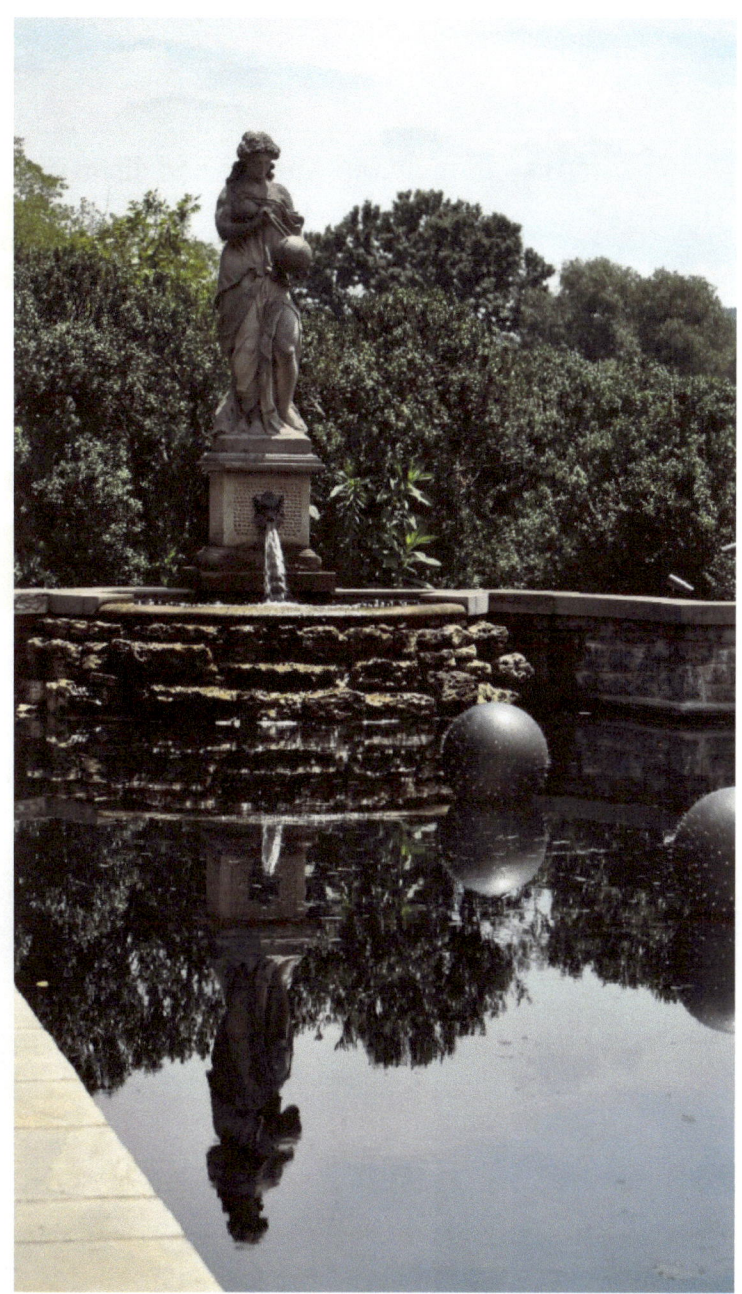

When I was a child, I talked like a child, I thought like a child, I reasoned like a child. When I became a man, I put the ways of childhood behind me. For now we see only a reflection as in a mirror; then we shall see face to face. Now I know in part; then I shall know fully, even as I am fully known.

And now these three remain: faith, hope and love. But the greatest of these is love.
1 Corinthians 13:11-13

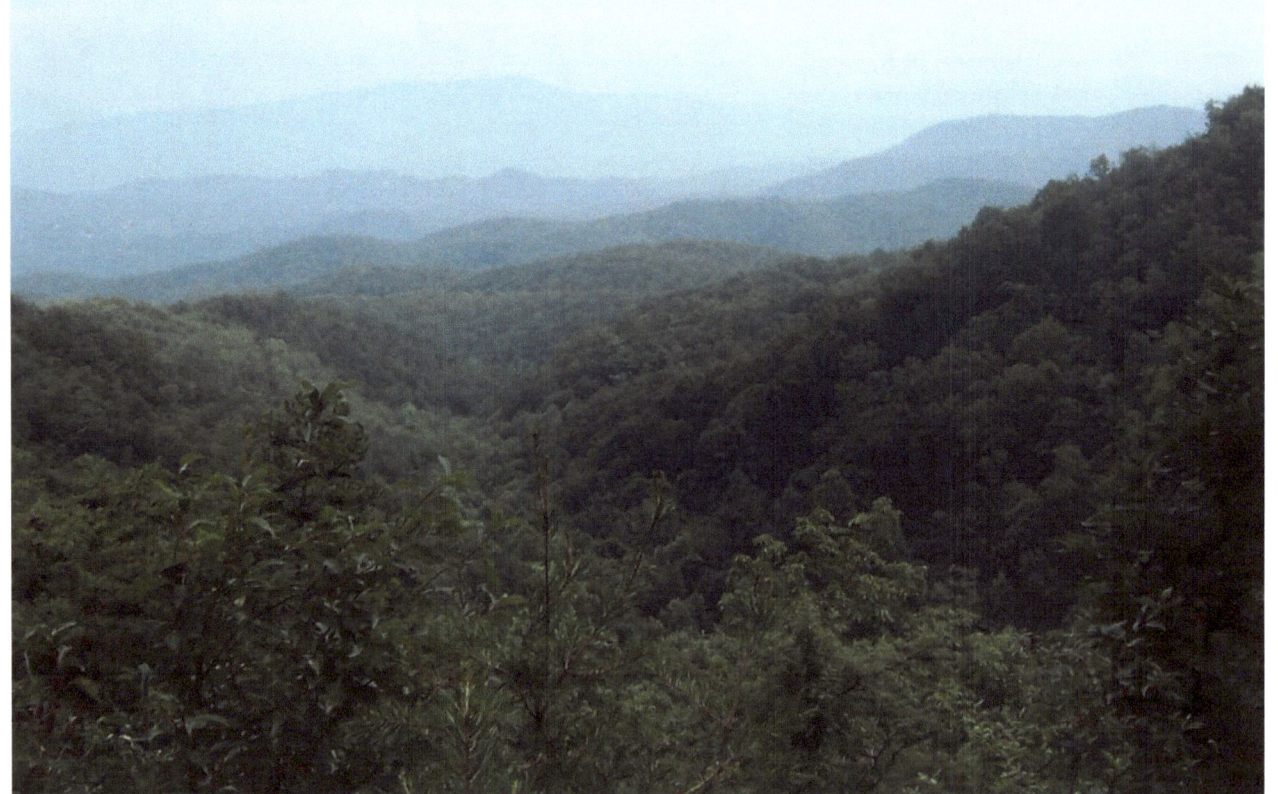

After he had dismissed them, he went up on a mountainside by himself to pray. Later that night, he was there alone, and the boat was already a considerable distance from land, buffeted by the waves because the wind was against it.

Matthew 14:23-24

God Given Eye

The thief comes only to steal, and kill and destroy; I have come that
they may have life, and have it to the full.
John 10:10

God Given Eye

Do not store up for yourselves treasures on earth, where moths and vermin destroy, and where thieves break in and steal. But store up for yourselves treasures in heaven, where moths and vermin do not destroy, and where thieves do not break in and steal. For where your treasure is, there your heart will be also.
 Matthew 6:19-21

God Given Eye

Let the fields be jubilant, and
everything in them;
let all the trees of the forest sing for
joy.
Let all creation rejoice before the
Lord, for he comes,
he comes to judge the earth.
He will judge the world in
righteousness
and the peoples in his faithfulness.

Psalm 96:12-13

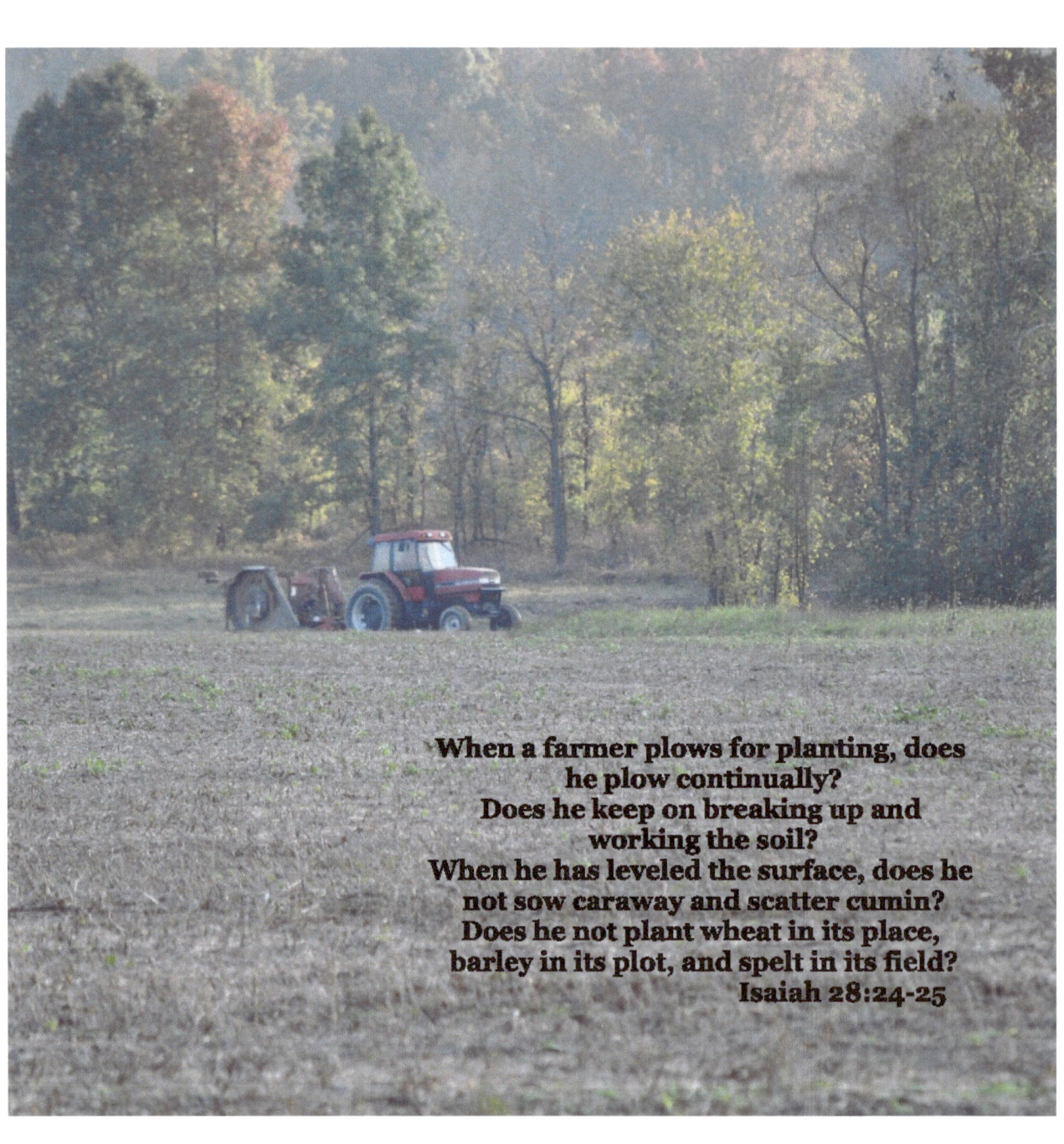

God Given Eye

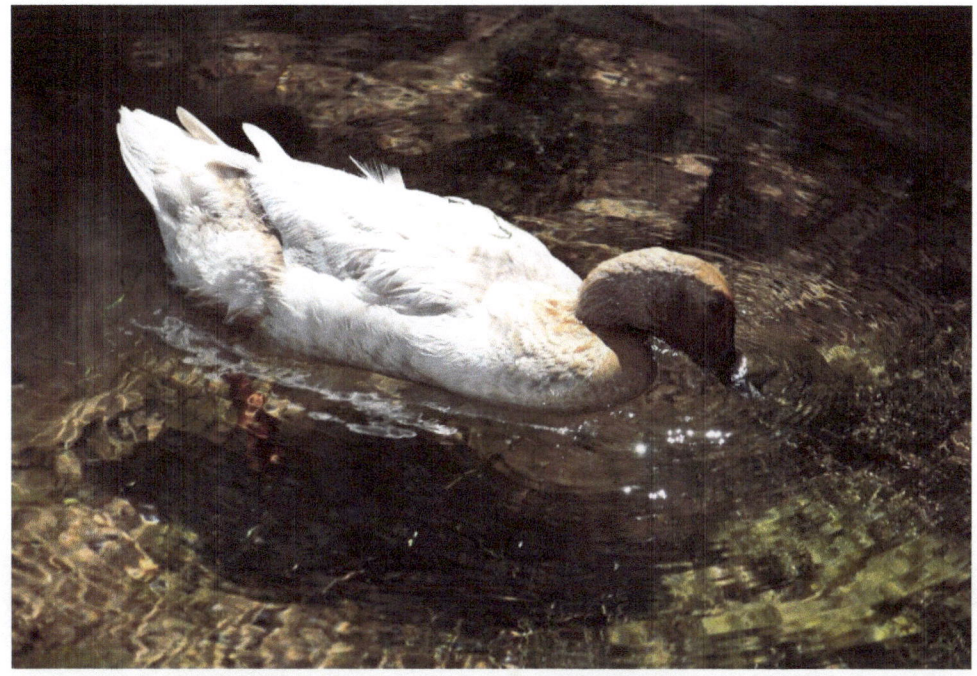

God made the wild animals according to their kinds, the livestock according to their kinds, and all the creatures that move along the ground according to their kinds. And God saw that it was good. Genesis 1:25

Blessed is the one
who does not walk in
step with the wicked
or stand in the way
that sinners take or
sit in the company of
mockers,
but whose delight is
in the law of the
Lord, and who
meditates on his law
day and night.
That person is like a
tree planted by
streams of water,
which yields its fruit
in season
and whose leaf does
not wither—whatever
they do prospers.
 Psalm 1:1-3

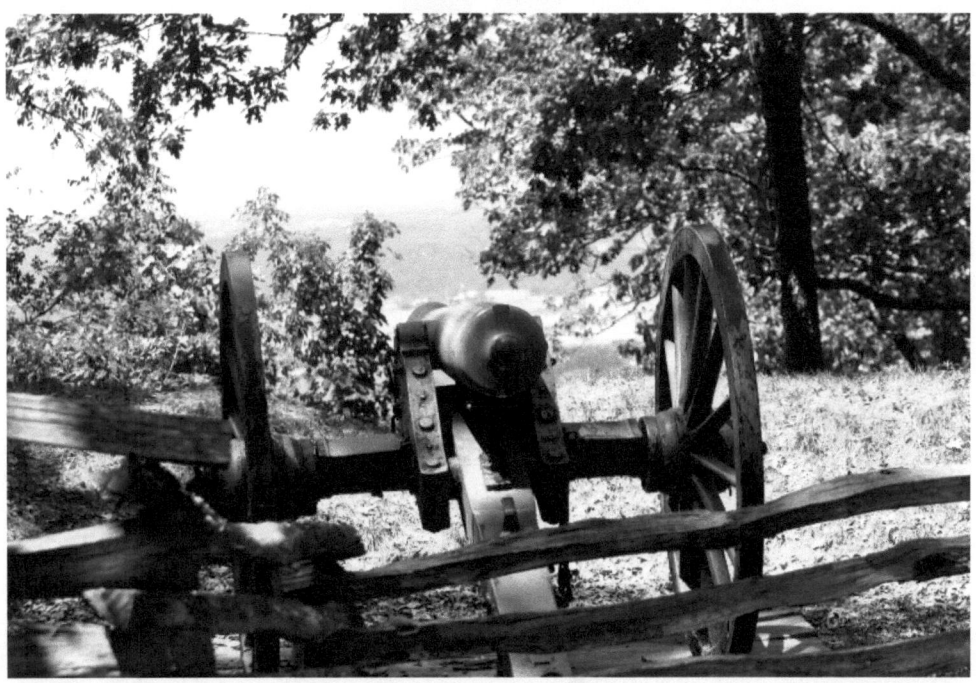

When you go into battle in your own land against an enemy who is oppressing you, sound a blast on the trumpets. Then you will be remembered by the Lord your God and rescued from your enemies.
Numbers 10:9

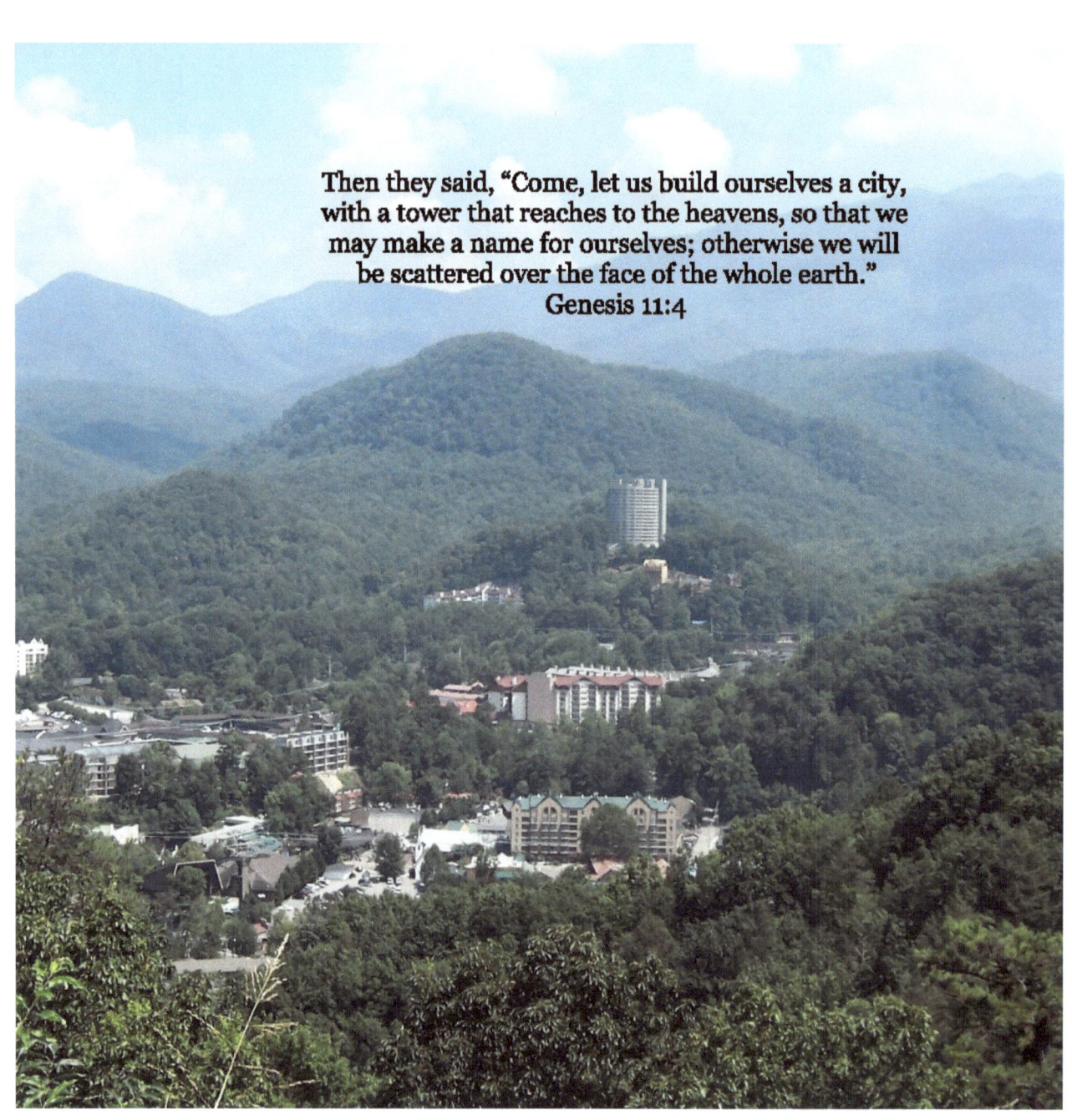

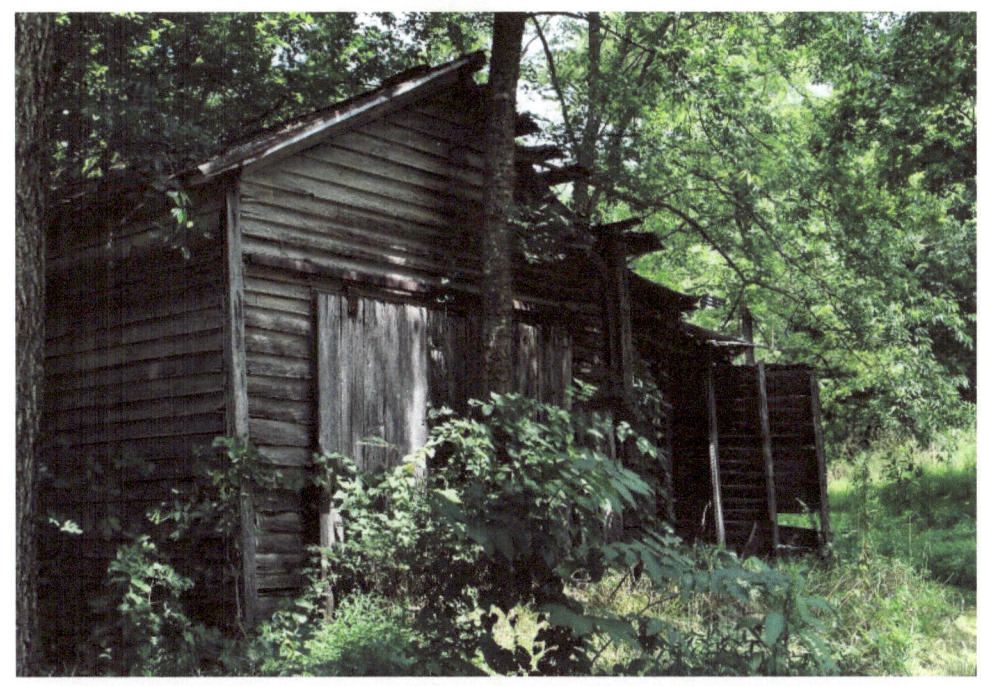

The Lord will open the heavens, the storehouse of his bounty, to send rain on your land in season and to bless all the work of your hands. You will lend to many nations but will borrow from none.
Deuteronomy 28:12

I was born in the small unincorporated town of Southside, TN, to a farmer and his wife in July 1971. The youngest of six children. Throughout the years, I had some type of camera in my hand. I remember my little 110 camera and saving my babysitting money to develop the film. I moved up to a roll of film 35mm and many disposable cameras. I got a digital camera by the time I was 30 and quickly upgraded to a newer digital with zoom lens and many filters. Looking back on my photo's, I know that God was with me through every step and every click of my camera. There is nothing too big for our God and he shows us in so many ways.

May this book encourage you in the midst of adversity and chaos that this world brings us everyday. God has shown me beauty, faith, love and mercy through every path. I cannot remember the text of scriptures or where they are found, but I remember these photos and now apply the scriptures to the image.

Visualizing the scripture to the photograph has helped me to carry the word of God in my heart when my mind can no longer remember. This is my sword when the enemy comes around.

May the Lord bless you and keep you.

www.ingramcontent.com/pod-product-compliance
Lightning Source LLC
Chambersburg PA
CBHW050750180526
45159CB00003B/1414